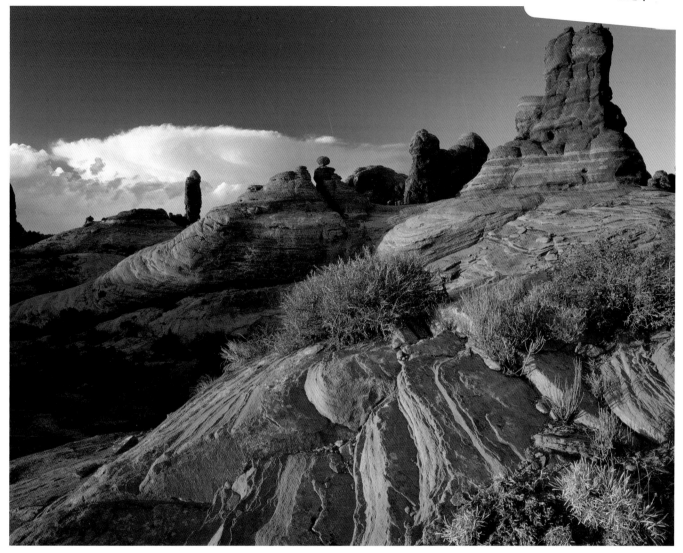

Landscape Within

First published 2004 by Argentum
an imprint of Aurum Press Ltd,
25 Bedford Avenue,
London WC1B 3AT

A catalogue record for this book is available
from the British Library.

ISBN 1 902538 34 X

Printed in Singapore

Designed by Eddie Ephraums
Set in Arrus and Gothic

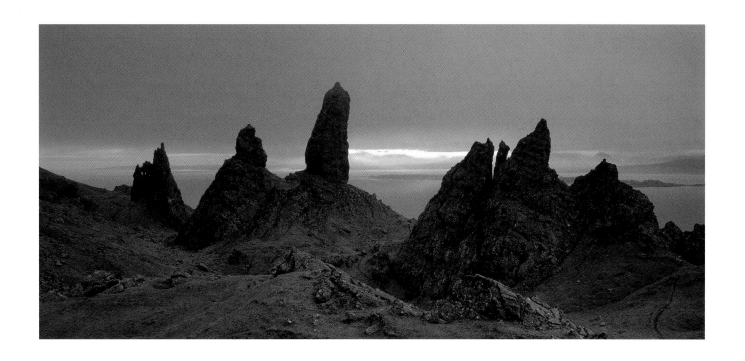

Landscape Within

Insights and Inspirations for Photographers

David Ward

Argentum

Contents

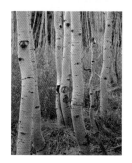
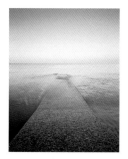
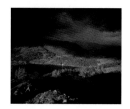

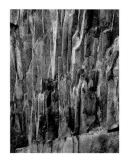

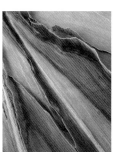

Foreword

David Ward breaks the mould utterly ... he shows that a photographer can not only write, but also explain, provoke, entertain, and above all inspire with his imagery.

Poll after poll by photo magazines shows that landscape is the most popular of all photographic genres for their readers. This popularity is reflected in the scores of books published on the subject each year, and hundreds of magazine articles. It would appear that those of us who love landscape photography are well catered for.

But the truth is that most books and articles are superficial. They may provide information on equipment, lots of focus on technique, some coverage of particularly photogenic locations, and perhaps a few anecdotes on experiences in the field. But very few ask: why? Or, what does this or that picture mean? And fewer still would attempt a philosophy of landscape photography.

It is not that fashionable to intellectualise anything these days, especially in the English-speaking world. Yet without analysis and thought it is difficult to truly comprehend and improve our work. Along with thinking must come the development of intuition or instinct, on our ability both to analyse and to feel, to be methodical and artistic. While the painter can scrape away and paint over his mistakes, the landscape photographer must make good decisions all the way through the process. Camera technique must be flawless, composition well crafted, and timing immaculate. It is the art form of good judgement, experience, and clear vision. A fusion of science, craft and art, landscape photography is an activity that draws heavily on mind, body and spirit. It deserves to be examined and understood in depth.

This book does just that, revealing the considerable philosophical and cultural significance of landscape photographs. David Ward shows how landscape has fascinated photographers since the earliest days of the medium, and how the status of photography as an art form has largely been fought for over the battleground of landscape. Among a wide range of issues, he questions the nature of human vision and perception and how photography creates an illusion of reality, and gives fascinating insights into transcendence, equivalence, romanticism and wilderness.

This is no dry academic account, however, for the author is a working landscape photographer with a passion for the natural world that began in childhood. (Although his photographic technique was honed in the advertising studios of London in the early 1980s, he has lived in a rural corner of Herefordshire for nearly twenty years.) We are talked to directly, with intelligence and wit, and his photographs are more than a match for his ideas. They follow the heroic tradition of American landscape photography, after Strand, Weston and Ansel Adams, although of course they are in colour, and as you will be able to tell from the humour, David Ward is unmistakeably English! This is a man familiar with all the photographic 'isms', British gritty documentary realism, the New Topographics, and the curatorial preferences for shock and

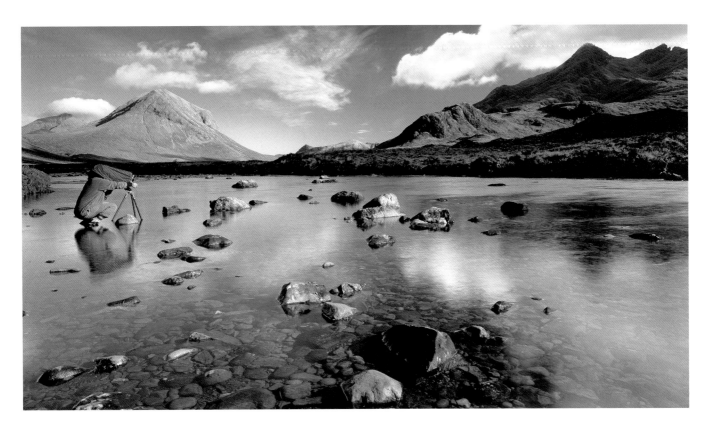

confrontation of the art establishment. So it is refreshing to find that the subliminal message in his personal work is rather simple, namely, that landscape and the natural world are something to be amazed at and inspired by.

He advocates the value of the miniature or intimate landscape, and the title of this book implies that. There are many great wide views here too. Close up or distant, his images are faithful documents of the landscape, windows on the outside world, yet they are also uniquely personal interpretations, mirrors of his emotion and passion for nature. This balance, between windows and mirrors, is itself a critical element of his text.

It is a generally accepted truism that few writers can photograph, and even fewer photographers can write. David Ward breaks the mould utterly. Fusing the ideas and philosophy of scientists, writers, art critics and thinkers, he shows that a photographer can not only write, but also explain, provoke, entertain, and above all inspire with his imagery. This may be his first book on the subject of landscape photography, but I for one hope it will not be his last.

Joe Cornish

As David says, 'Every time we press the shutter we need to make a leap of faith as well as a leap of the imagination.'

7

Introduction

It seems to me that the heart of photography has, perhaps paradoxically, very little to do with cameras and technology.

I love *landscape* but I loved the *land* first, not just those bits that fit neatly into the camera's frame. This affair began long before I thought to make landscape photographs.

I don't really recall when I fell under its spell but it must have been when I was at primary school. I grew up in the Green Belt surrounding London – not the most auspicious start for a lover of wild landscapes. Protected by post-war legislation from blanket development, the land here was part suburban sprawl, part manicured agricultural land and part ancient forest. None of it approached what one might term wilderness. My childhood days, outside the confines of the classroom, were spent, rain or shine, in the beech woods near my home: climbing smooth beech limbs slick with algae and falling onto the musty leaf litter; building dens in the chest-high green bracken and the hollow trunks of the oldest trees; fishing in a stagnant pond – though I never caught a fish; watching leeches I had captured in a jam jar perform their slow, creepily balletic movements in the cloudy water; kicking through golden drifts of fallen leaves and running or riding my bike on the treacle-black muddy paths between the towering trees. Setting aside the details, mine was a fairly typical childhood in semi-rural England. I would venture that it was fairly typical of the childhoods of many boys, and girls, growing up in the 1960s across a large part of Western Europe and the USA. Freed of previous generations' need to work on the land, the fields and woods were now solely our playground.

But this land wasn't 'landscape'. It was just my everyday surroundings, my backyard. I think the first time I thought part of the world fitted that special category was on a childhood holiday in autumn to the English Lake District. Neither of my parents were keen walkers, so much of the holiday was spent driving around to look at the sights. The Lakes are, of course, infamous for the local climate's high rainfall. I recall most of my days being spent confined to the back seat of the car staring out through a partially misted window at brown hills, their tops lost in low grey cloud, while fat rain drops beat against the glass. However, on one afternoon we were driving from Windermere to the small village of Glenridding, in the northern Lakes, when the clouds began to part. A sky that had moments before seemed steel-grey now took on the tone of black slate in contrast to the brightly lit fells clothed in orange bracken. As the narrow road we were travelling climbed the fellside beyond Troutbeck, a screen of trees to the right fell behind us and revealed a vista. We were now quite high above a broad valley. Looking through the rain-smeared car window, I could see a long tongue of high land intruding into the u-shaped valley. Sitting at its foot was a whitewashed stone farmhouse. Sheep grazed amid a web of dry-stone walls that extended across green fields to a distant, higher, undulating ridge of hills. Above it all a rainbow arced across the dark sky.

Click! Or rather not — because I didn't yet own a camera.

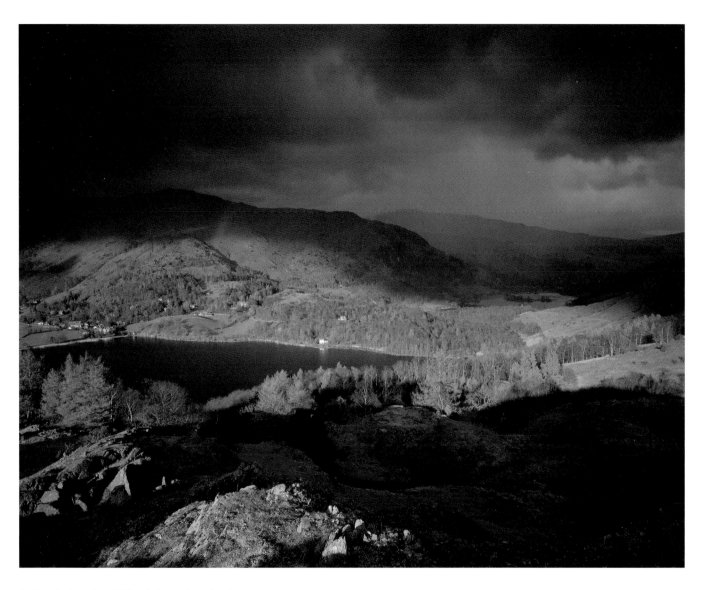

*Looking back at that childhood day in the Lakes I
wonder what moved me to make the distinction between
land and landscape.*

What you need to cultivate first and foremost in photography is, I believe, your vision; you need to train yourself to really see, not just glance around you but to concentrate totally on your surroundings.

Looking back at that childhood day in the Lakes I wonder what moved me to make the distinction between land and landscape. Was it something about the light, the juxtaposition of weather and landform that transformed my field of view into a picture? Was it a reflection of seeing similar images, a thousand picture postcards or perhaps Constable's painting of Salisbury Cathedral? Why is it that one view is considered worthy of representation and another not? My motive for writing this book is to try to answer these and other questions about my own practice, to try to answer why I make my images and why some succeed and others do not. In other words, to try to peer into the essence of photography.

The Lake District is one of the birthplaces of artistic appreciation of the landscape. So, it's perhaps not surprising that I should have my eyes opened here to the important distinction between land and landscape. I find it more interesting that the first time I remember the world as landscape was when I was looking at the outside world through a piece of glass surrounded by a frame. That arrangement is temptingly analogous to a camera and its significance is that it presented me with a ready-made selection of the world. The difference between land and landscape is that landscape is always a selection.

When practising my photography I sometimes feel that I'm chasing a chimera, an unobtainable illusion. The goal is as insubstantial as water vapour. Someone once likened love to quicksilver; you can hold it in your upturned palm, but if you close your hand it slips away through your fingers. When I think of photography, and what it is about it that fascinates and enthrals me, its essence seems just as slippery and shiny as that mercury. You can see your own distorted image in the surface but cannot penetrate beyond the reflection.

It seems to me that the heart of photography has, perhaps paradoxically, very little to do with cameras and technology, very little to do with the endless writing about hyperfocal distance or the rule of thirds or AE lock. The essence is not a simple single truth but a range of related answers, though what the questions are is not immediately apparent. To find answers about what anything is made of we need to look at the underlying structure, not simply make superficial dissections. Any investigation will have to address a series of questions about how the mind works and apply those results to photography. How does the mind make sense of the world around us? What are the differences between what we see and the representation made by a camera?

The old saying goes that a picture paints a thousand words. How? What processes go on in our minds when we look at an image? Does what we see and our interpretation of it always relate to labels, to language? If we exclude easily identifiable objects from the frame, if we make an abstract image, what then of the labelling process?

We've all seen, and indeed made, images that are technically good and compositionally adequate, yet for some reason they fail to ignite our passions. Why do these photographs, for want of a better term, lack soul?

Just what is it that's missing?

You've probably struggled for years, as I have, to master various techniques and spent a small fortune on the latest gadgets. All this study and not inconsiderable expense has brought you to a plateau of technical achievement that many see as an end in itself. But technical perfection alone is not enough; it will never be inspirational, never make another human's heart beat faster, never bring a tear to another's face. To achieve these things we need to reach beyond the competent and the merely illustrative. We need to look for how to communicate emotion through art. We're reaching for transcendence; the evocation of something beyond the mere description of what's in front of the camera. When an image achieves this the message it imparts is more than the sum of the tones and forms that are amassed in the frame, more than the sum of labels that can be attached to its contents. I believe that progress as a photographer involves becoming more adept at incorporating this elusive element into our images. The question is, how? What's the secret to making an image transcendent?

What you need to cultivate first and foremost in photography is, I believe, your vision; you need to train yourself to really see, not just glance around you but to concentrate totally on your surroundings. But 'Vision' is often seen as the province of gifted individuals and not as something we can learn. I believe we should recognize the potential for creative vision in all of us. If the possibility for artistic expression is open to all of us, how can we tap this potential and where does our creativity come from?

This is, as a friend perceptively remarked when we discussed my original ideas, a 'why book' rather than a 'how to book'. That doesn't mean, however, that there won't be pointers as to how to make landscape images and these will be scattered throughout the text and more strongly concentrated in the final section. I would like to make clear, however, that the accompanying photographs, whilst some are mentioned specifically in the text, are not illustrations of the text. They exist as statements in their own right and as a parallel story to the words.

I don't expect to produce a definitive picture of the essence, rather I want to inspire photographers to undertake a deeper quest for themselves. I intend to address questions by looking at a variety of different topics and disciplines – the histories of art and photography, psychology and philosophy. I want to focus on the mind as well as the visual and the social; I want to begin an exploration of how our interior landscape affects our portrayal of the world around us and our understanding of the portrayals made by others. I hope that this exploration will help you gain an insight into the creative process and, en route, find some inspirations for making photographs of your own.

Why is it that one view is considered worthy of representation and another not? My motive for writing this book is to try to answer these and other questions about my own practice, to try to answer why I make my images and why some succeed and others do not.

11

Susan Sontag proposed a continuum of meaning in photography between the two poles of beauty and truth: beauty stands for self-expression and a concern with aesthetics and emotions whereas truth stands for communication.

1

A
River
of
Light

The bond between photography and reality

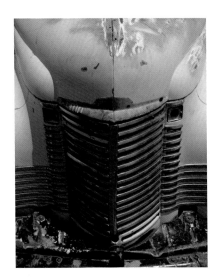

A photograph can be thought of as being transparent no matter which process, negative/print or transparency, was used to obtain the image.

Photographs are ubiquitous, indeed they are so woven into the fabric of everyday life that we scarcely give them a second thought. As photographers we know well enough the technical processes involved in producing a photograph but often shy away from thinking about how those processes affect our perception of it. I want to explore how the way in which a photograph is created has deep implications regarding how we think about the contents of the frame.

Here's a provocative idea: a photograph can be thought of as being transparent no matter which process, negative/print or transparency, was used to obtain the image. This statement appears to be nonsense but I'm not referring to the physical attributes of a photograph but rather to how our minds perceive the information contained within the frame. For most uncritical viewers, photography and direct vision are felt to be interchangeable, the only difference being the degree of separation. How often have we heard someone looking at a photograph exclaim, 'Oh, it's just as if I was there!'

A photograph is transparent, on a first, cursory look, partly because we ignore its physical presence. We are, of course, aware that a photographic print has substance; it has a little weight, a certain thickness and a glossy or pearl finish. But we frequently disregard these attributes when we look at one; like a mirror or window, the image we see is not projected on the surface but on another plane. We see through its surface to a slice of reality almost in the same way as if we were staring through glass. We tend to think of photographs as a window on the world, never more so than when we view projected transparencies in a darkened room. The photographic image is perceived as a direct translation of reality partly because it is in many ways optically congruent with human vision. But there is another reason that springs directly from the river of light that links the photograph to the object portrayed.

William Henry Fox Talbot, the English inventor of modern photography, tellingly entitled his first book of photographs *The Pencil of Nature*, a phrase that seems to allude to our harnessing an inherent ability for the natural world to portray itself, to hold up a mirror so that we may see it unmediated by the hand of an artist. The Japanese word for photography reinforces this idea since it translates as 'reflections of the truth'. The medium's English name, derived from Greek, proclaims, perhaps a little less confidently, that we are drawing (directly) with light.

We are normally unconscious at the time of viewing of the photograph's transcription of four dimensions onto a two-dimensional surface. The French philosopher Roland Barthes wrote that the photograph represents, 'neither image nor reality, a new beginning … a reality one can no longer touch'. When looking at a photograph we are transported to that other reality contained within the frame. We grant the photograph an elevated status of veracity because there appears to be an embedded link between the object photographed and a 'straight' photograph of that object that is not present in a watercolour, gouache, acrylic, montage or any other representational process. Obviously this only partially applies to an image that has been mechanically retouched (as the Pictorialists were wont to do) or (since we live in the digital age) altered in Photoshop. We'll get to the implications of these manipulations in a while. We can be

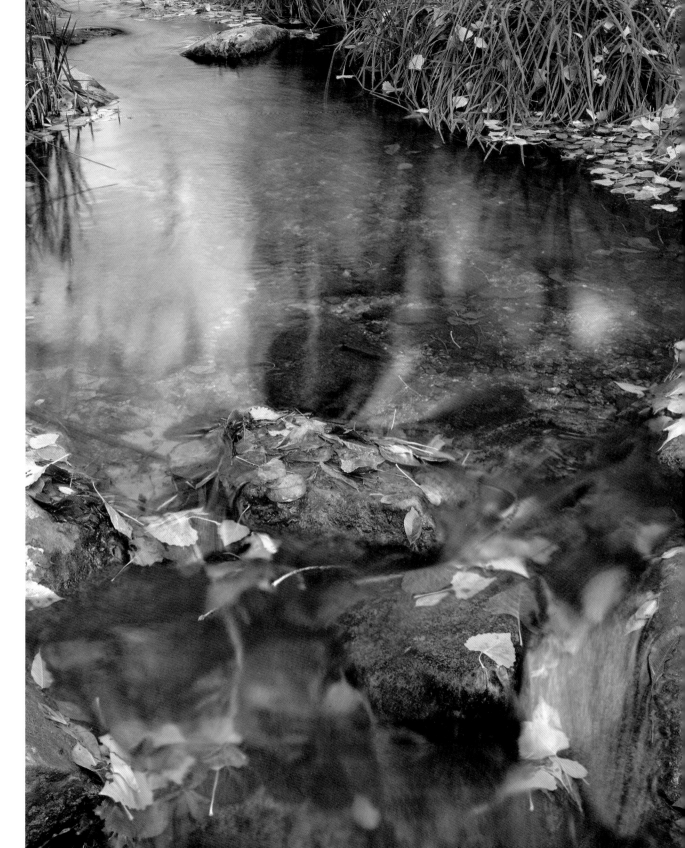

It is precisely
because the
bond between
reality and
photography
confers a
special status
of objectivity
upon the
photograph ...
that we feel
particularly
cheated by a
manipulated
photograph.

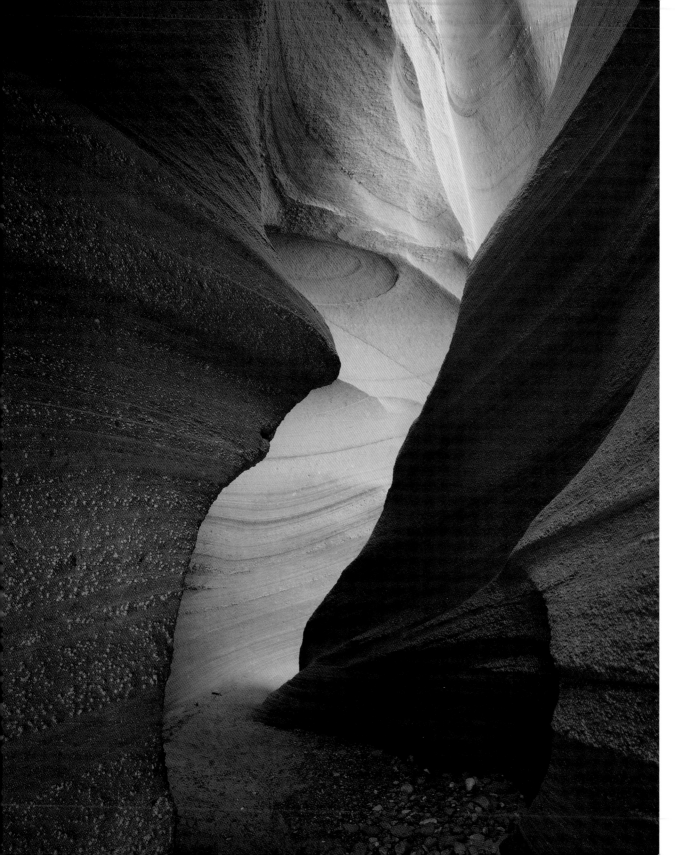

*The power
of the
photographer is
seen as the
depiction of
'truth', in
direct
opposition to
the other visual
arts where
manipulation,
or
transformation,
of reality by
the artist is
thought
essential in
order to grant
an image the
status of art.*

absolutely sure that, at the moment the photograph was made, the object portrayed existed, something we cannot say with certainty of a painting or sculpture. A 'straight' photograph's very existence depends upon light reflected from the object passing through the lens of the camera and transcribing a latent image in the photographic emulsion. The portrayed and the portrayal hence appear to be in some profound sense bound to each other: the photograph is anchored to reality by this transient and insubstantial ribbon of photons. Roland Barthes noted that the photograph refers 'not to the optionally real thing to which an image … does but to the necessarily real thing which has been placed before the lens, without which there would be no photograph'.

Verisimilitude in painting was once seen as the ultimate goal but instantaneous photography changed all that. The eminent French painter Louis-Ernest Meissonier specialized in historical subjects including battle scenes. He was particularly proud of his ability to depict horses in motion, having spent decades making studies of their movements from real life. In 1879 Leland Stanford (the railway tycoon, horse fancier and financial backer of Eadweard Muybridge's work) presented him with Muybridge's photographic motion studies of the horse's gait. It was immediately apparent to Meissonier that he had been deceived by his own vision and had not in fact represented the true motion of a galloping horse but some artefact of his own fallible human perception. In despair, he declared, 'After thirty years of absorbing and concentrated study, I find I have been wrong. Never again shall I touch a brush!' Painters had often sought to portray a kind of hyper-reality, an imagined conjunction of dramatic figures at the significant moment, but now found themselves to be deficient when compared to photography's effortless mimesis of the everyday world. More than that, photography granted access to a reality beyond human vision. Fox Talbot's 'pencil of nature' threatened to vanquish the artist's brush, so it is unsurprising that some artists chose to traduce photography's achievements by declaring, as August Rodin did, 'It is the artist who tells the truth and photography that lies. For in reality, time does not stand still.'

David Bailey once suggested, 'You need less imagination to be a painter, because you can invent things.' Or, to put it less facetiously, as Arthur Chandler wrote in his essay 'From Plato's Cave', 'the painter is in some sense freer than the photographer. The painter can conjure up souls long since vanished from the face of the earth, or place all people – real or imagined – on his canvas stage in pre-planned attitudes of hope or despair, rage or indifference … The world behind the picture plane is the artist's own.' Even if extreme forms of manipulation – coloured filters, effects filters, motion blur, extended exposure, multiple exposure, drop focus – are applied to the photographic image, it is still bound to reality in a more profound way than a painting because photography must work with the material in front of the lens. As the great American photographer Paul Strand declared, 'Objectivity is of the very essence of photography, its contribution and at the same time its limitation …'

A painter can produce an image that, whilst using reality as its basis, bears very little resemblance to the original subject. In fact this manipulation, this translation or mutation of

The photograph represents, 'neither image nor reality, a new beginning … a reality one can no longer touch'.

Roland Barthes

reality has been seen as the core of a painter's artistic genius, from Turner to Magritte to Monet to Picasso and Salvador Dali. By altering the proportions, colours and arrangement of elements within a scene, the painter with insight and sufficient technical skill can manipulate our emotional response to the subject. In fact a painter doesn't have to depict reality directly at all. If we think of Picasso's famous painting *Guernica* there is little that directly represents the bombing of the eponymous Spanish village by Hitler's Luftwaffe at the request of General Franco's fascists. Rather, the image is concerned with portraying the suffering of the victims in an abstract, allegorical way that is no less effective for turning its back on verisimilitude. Indeed, it could be argued that photography impelled the other visual arts to explore rich avenues of non-representational expression.

A 'straight' photograph's very existence depends upon light reflected from the object passing through the lens of the camera.

People will often remark on a fine photograph, 'The photographer must have a really good camera!', a comment that is, I think unintentionally, a backhanded compliment. I doubt, though, that anyone suggested that Titian's skills as a painter rested entirely on the quality of sable used to make his brushes. The comment reflects a feeling that the equipment plays a more important role in the production of a photograph than the photographer does, a feeling that is used as a justification for demeaning the value of photography. The apparent ease with which a photograph is created produces mistrust; how can something so easy be worthwhile? In a way we only have ourselves to blame; almost since the beginning of photography, camera and film manufacturers have promoted the myth that making good photographs is facile. A company called Fallowfield even manufactured a 'detective' camera called 'The Facile' in 1890. It used multiple glass plates and was intended for covert operation. The rather bulky mahogany box (measuring 11 by 5 $\frac{1}{2}$ inches by 8 $\frac{1}{12}$ inches high and weighing 6 lb) was supposed to be disguised as a parcel by being wrapped in brown paper when in use. A snap shot camera it wasn't!

Today, a commonly held view about making photographs is 'You just point and shoot!' In the last twenty years camera makers, with the advent of electronics in cameras, have trumpeted the genius of their technology, promoting how amazingly smart their metering systems are, how incredibly flexible and intelligent their built-in exposure modes. This promotion of technology for simple commercial gain throughout the history of photography has led to the commonly held belief that there is some transfer of creative responsibility from the photographer to the equipment.

Were we not abdicating an element of our creativity by assigning image-making to a mere mechanism? This handing over of the task of creation to a machine causes unease. For a long time photography's objectivity was cited as a barrier to it becoming an art but I think that the opposition was not simply against the camera's faultless mechanical mimicry. At a time in the nineteenth century when the skills of craftsmen such as weavers were being usurped by machinery, here was proof that even artists weren't safe from the march of progress. The really worrying thing for established media was that image creation was now theoretically open to all and no longer the preserve of gifted individuals – after all, anyone could press a shutter

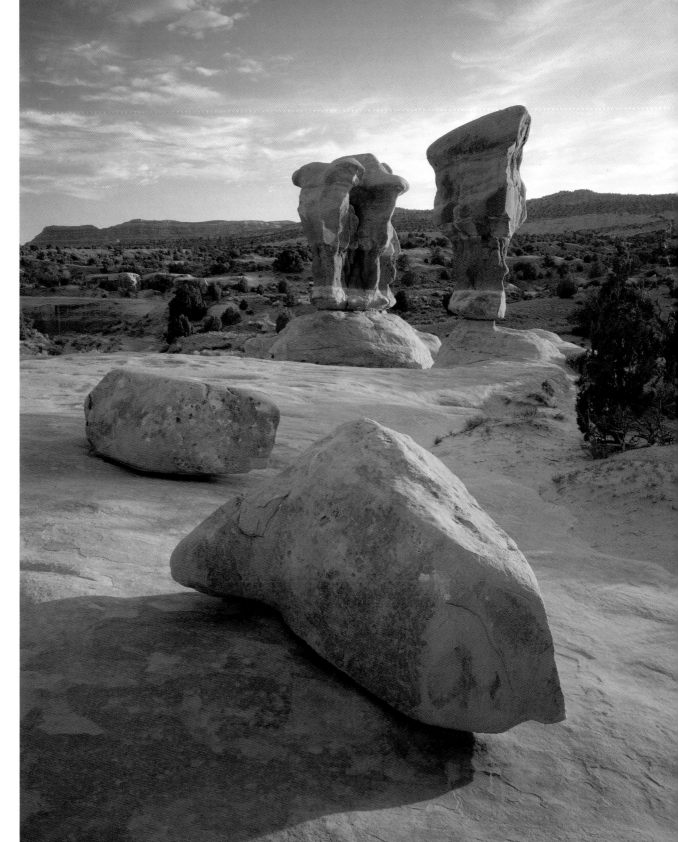

*The portrayed
and the
portrayal hence
appear to be in
some profound
sense bound to
each other: the
photograph is
anchored to
reality by this
transient and
insubstantial
ribbon of
photons.*

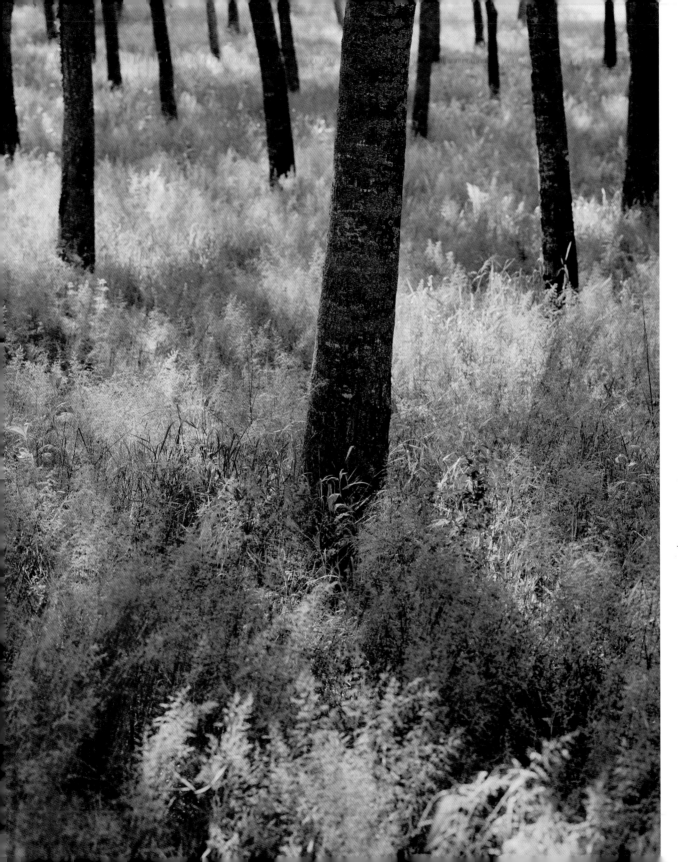

A photograph might take only a moment to make, but follow weeks of waiting to ensure being in the right place at the right time.

button. What was also at stake, and still is to an extent, was a matter of pride in craft, a pride in manual dexterity and in our ability to create something magical from unprepossessing materials. Human genius lies not just in our vision but also in our ability to directly manipulate the environment; it lies in our skills at hewing stone or daubing pigments on a canvas. Today we extol the hand-made, sometimes however poorly it is crafted, and tend to malign the machine-made. And photography is still tainted, to a certain extent, by association with the mechanical.

Groucho Marx once said to his long-suffering 'straight-man' Margaret Dumont, 'Who are you going to believe, me or your *own* eyes?' – a gag that plays on our perceived equation of vision with truth. The two concepts have long been linked to each other by common sayings: 'We have an eyewitness', 'I won't believe it till I see it with my own eyes' and most directly 'Seeing *is* believing.' If no person was present to witness a crime then we willingly accept a blurry photographic image from a CCTV camera as the next best thing to an eyewitness. A photograph is – in the sense that we 'believe in it', that we 'have faith in it' – little different from direct perception of reality through our own eyes. 'The camera never lies' is an extension of this notion, reflecting the popular belief that the evidence presented in a photograph is actually the unequivocal truth. The selection performed by the photographer collapses all the possible views of a subject into a single view that conforms to human vision. In this way it fools viewers into thinking that this might have been their perception had they been standing there – your perception of the subject has largely been imposed by the photographer yet you feel that it is still your own. The commercial world has long accepted this link between photography and perceptions of truth. When advertisers seek to impress us with the veracity of their claims for a product they invariably use a photographic image rather than an illustration. Countless retouched images of beautiful women have been employed to prove the worth of cosmetics. We might not believe written claims alone but backed by an artfully constructed photograph they seem irrefutable.

So let's be cautious, because, as someone once said, whilst the camera cannot lie, 'it cannot help being selective'. No matter how objective the image appears to be we are always as selective with our interpretations of photographs as we are with the choice of view. When Clarence King employed Timothy O'Sullivan to take photographs for the Fortieth Parallel Survey of 1867, he had in mind a grander enterprise than mere topographical record-keeping; he was a man with a mission. The survey was instigated to pave the way for the settlement and commercial exploitation of the land west of the Mississippi. O'Sullivan's images are striking to us today for their apparent modernity and their lack of stylistic conceit. It is easy to see them as coolly factual, as documentary evidence of the lie of the land to accompany geological and topological reports. But King, an adherent of Louis Agassiz' theory of catastrophism, had another agenda for the images. The catastrophists rejected Charles Darwin's theory of evolution and believed that the world had been periodically wiped clean of life by violent geological upheavals after which God then instigated creation anew. Agassiz was an enthusiastic supporter of the then radical theory that the world had undergone cataclysmic ice ages. These, he thought,

We willingly accept a blurry photographic image from a CCTV camera as the next best thing to an eyewitness. A photograph is – in the sense that we 'believe in it', that we 'have faith in it' – little different from direct perception of reality through our own eyes.

had wiped the slate clean, expunging life and making way for a new beginning. This catastrophic annihilation allowed them to dismiss the fossil record as proof of continuous evolution and, by a sort of intellectual sleight of hand, proclaim that fossils were just evidence of previous creations – they 'proposed that Man, established after the last upheaval, was shaped by God's handiwork evident in the landscape'. King saw the hand of God in the forms of nature and believed that the American landscape, in particular, showed traces of the last catastrophe. O'Sullivan's photographs were used in an attempt to illustrate this theory with photographic evidence. The images certainly showed a rugged and almost primeval landscape but whether that was proof of Agassiz's theory or not is quite a different matter. When we think of a photograph as the truth we must be careful to distinguish the representation from the meaning attached to it. In the end it seems likely that even King could not reconcile his belief in catastrophism and the 'evidence' in O'Sullivan's images with the growing weight of geological and other scientific evidence in favour of Darwinism: he eventually went mad in Central Park, New York in 1893 and was committed to an asylum.

It could be argued that photography impelled the other visual arts to explore rich avenues of non-representational expression.

It's often easy, but erroneous, to believe that the photographic image is unmediated, unimproved and unpolluted by the hand which operated the apparatus. (One aspect of the overpowering reality in a photograph is that the style of the image is sometimes invisible.) In fact, today, countless faked photographs have to some extent reduced the faith we place in photographs, in a way that a faked portrayal on canvas could never reduce our faith in painting. How can you fake something that is as subjective as painting? It is precisely because the bond between reality and photography confers a special status of objectivity upon the photograph, in opposition to all other forms of representation, that we feel particularly cheated by a manipulated photograph. Photographic practice is in a sense caught in a Catch 22 situation; it is still disdained by some art critics for being ineluctably wed to reality and yet when a photographer manipulates his image he is condemned by his fellow practitioners as a cheat – but only up to a point!

It might seem that the level of manipulation is irrelevant to purists. I'm often asked if I moved the leaf in 'Red Maple' (see page 92). The thought that I might not have found it 'just so' seems to cause offence, or at least a slight frisson of disapproval. There seems to be some unwritten rule, 'Thou shalt not shift things around in the frame!' I can see that something as blatant as constructing a montage (easily done in the digital age) could offend some purists, but so might something as subtle as filtration (although not all filtration is subtle) or as invisible to the viewer as arranging the objects in a scene before making the picture (perish the thought that I would ever do such a thing!). The possibility of 'fiddling' with reality is at the heart of the bitter rearguard action fought against digital imaging by film traditionalists.

Of course, one often cannot render reality on colour film in a way that corresponds with human vision without using filtration. We commonly use 81 series filters to correct for the coldness of overcast or sky-lit shadows. These filters make the image match up with how we see in these conditions; they approximate to the complex corrections our minds make to solve the

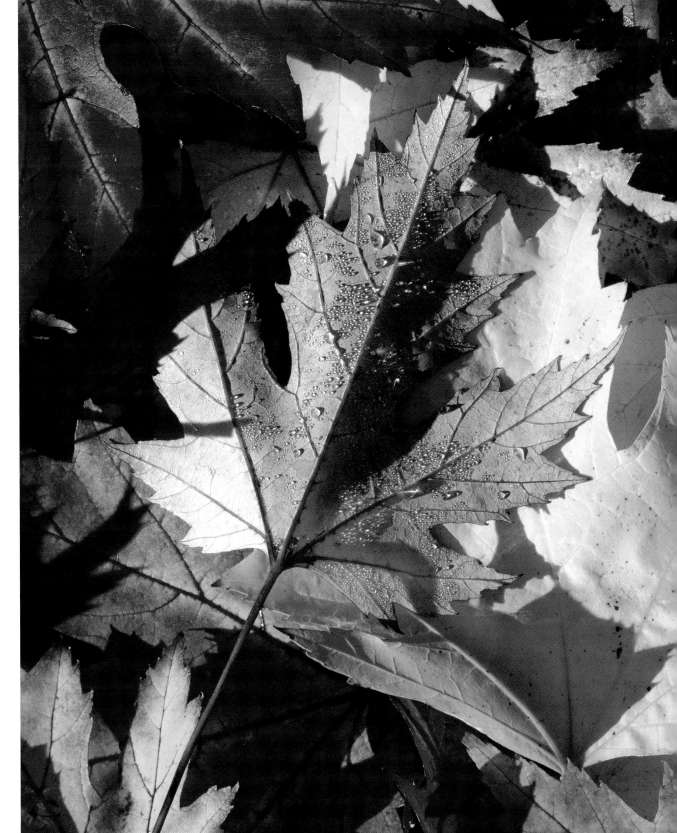

It is said that beauty is in the eye of the beholder but we would do well to remember that the truth is just as subjective.

colour constancy problem. The irony is that an unfiltered image like 'Blue and Gold' (see page 000) is more real in its representation of colour than human vision. So, if in 'Blue and Gold' the film represents the colours closer to how a spectrometer would 'see' them than to how we see them, which is the truth?

The argument against manipulation by the photographer seems to be that whatever has been done has affected the base reality, and consequently its depiction, and is hence wrong. This is a moral rather than an aesthetic argument, and one that is often only loosely applied. There is a very large sign on one wall of the great landscape photographer Michael Fatali's gallery in Springdale, Utah, proclaiming that none of his images have been manipulated, that no colour filters have been used nor has any digital trickery taken place. The implication that what you see in the print is what the photographer saw at the time the image was made is, at the very least, being economical with the truth. Michael Fatali is an heir to the venerable American tradition of the fine-art print and spends a great deal of time in his darkroom. His consummate technical ability as a printmaker produces amazing prints that categorically are not exactly the same as the reality in front of his 10x8" camera when he opened the shutter.

Why, then, does he feel the need to claim that these prints are not manipulated? I would argue that it is because the power of photography, as a means of artistic expression, has often been seen to reside in the particular photographer's genius in choosing which portion of base reality to enclose within the frame and, just as importantly, the significant moment to perform this selection. The depiction of such a choice has more power if it is seen as the 'truth', if it is seen as being unmanipulated, for as Ansel Adams wrote, 'Not everybody trusts paintings but people believe photographs.' The reasoning runs something like this: how much more astute and insightful is the photographer who has the genius to note and record a significant portion of unadulterated reality than someone who has to concoct something. This stands in direct opposition to the other visual arts where manipulation, or transformation, of reality by the artist is thought essential in order to grant an image the status of art (of course any depiction of three dimensions in a two-dimensional space is a transformation, as we shall see in Chapter 6).

It is significant that Fatali specifically mentions digital manipulation. The problem for purists isn't just the alteration of reality; it's also how easily that alteration might be effected. A photograph might only take a moment to make, but follow weeks of waiting to ensure being in the right place at the right time. A photograph can achieve an elevated status as a 'significant truth' from the struggle to capture the moment, and never more so than within the genre of landscape. From the purist's standpoint, it's one thing for a craftsman to spend hours manipulating a print in the darkroom to bring out the best in his image, having invested the time in the field, but another thing altogether for some spectacular view to be achieved by a few mouse clicks and then presented in a form that is thought inherently truthful. It is seen as seriously weakening the only weapon that photography has to counter the supremacy of other forms of visual representation.

'The photographer must have a really good camera!' reflects a feeling that the equipment plays a more important role in the production of a photograph than the photographer does.

For practitioners working in the fine-art print tradition, the original image (whether captured digitally, on colour transparency or b/w negative) is just the starting point, the 'score' in Adams' terminology, and the print the 'performance'. Fatali is altering the depiction of reality no more than Ansel Adams did when he produced monochrome prints. No photographer imagined that Adams' prints were 'straight' but such manipulations as were applied to the prints were thought of as naturalistic, as plausible. Working on the print is deemed to be legitimate. More than that, manipulation by the photographer at the printing stage confers artistic individuality to the print; it is the manner in which a photographer can literally make his mark upon a mechanical representation. The problem for photographers who champion the 'straight' approach is that morally this fine-tuning is no different from, though less visible than, the Pictorialist's obvious manipulation of photographic images.

This highlights photography's complex relationship with objectivity and subjectivity. Both the Pictorialists and photographers such as Adams and Fatali are seeking to affirm the dominance of the subjective over the objective. But this oversimplifies the case. Photographs are never wholly objective nor wholly subjective. Susan Sontag proposed a continuum of meaning in photography between the two poles of beauty and truth: beauty stands for self-expression and a concern with aesthetics and emotions whereas truth stands for communication. The former is not concerned with a correspondence between the image and reality whereas the latter seeks to illuminate such a relationship. You might think of Fatali as batting for beauty and someone like the press photographer Robert Capa on the side of truth. But Fatali seems to be seeking to validate beauty with truth, to ratify his subjectivity with photography's objectivity. Because photography's link to reality (the truth) is thought to be over-riding, the manipulated image is left open to being criticized as a blatant lie. This is why Fatali and, indeed, most photographers feel the need to call on the services of objectivity: quite simply to refute any possible accusations of mendacity.

The possibility for a photographic lie is the reason why people feel uneasy about manipulation of the subject and why they ask me if I moved the leaf. It is said that beauty is in the eye of the beholder but we would do well to remember that the truth is just as subjective. We all want viewers of our images to believe that the beauty we represent is 'true' beauty.

In the making of any photograph the photographer intervenes on numerous occasions to make subjective decisions. The camera is a conduit for the image, a connection between external reality and the film emulsion, in a process controlled by the photographer's mind and mediated by the technical limitations of the equipment at hand.

A photograph is objective only in as far as the light entering the lens has faithfully delineated a representation of the view in front of the camera. In all other respects it is subjective; the choice of viewpoint, framing/composition, lens, filtration, film stock and moment are all essential subjective decisions which determine how the photograph will look; the interpretation by the viewer is by definition subjective.

There can be no objectivity beyond the gathering and rendering of light because there is no universal definition or measurement applicable to the making or viewing of a photograph. There can, therefore, be no such thing as the 'best picture'. Like cooking, photography is a matter of taste, a matter of relative not absolute value.

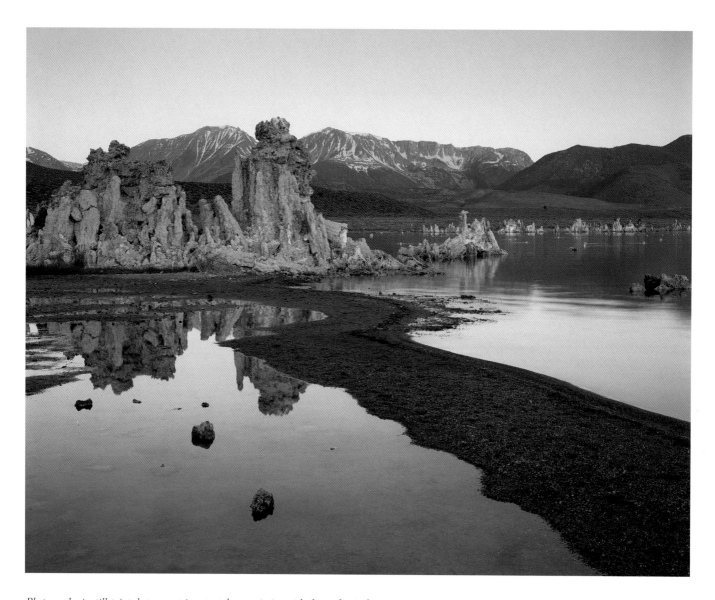

Photography is still tainted, to a certain extent, by association with the mechanical.

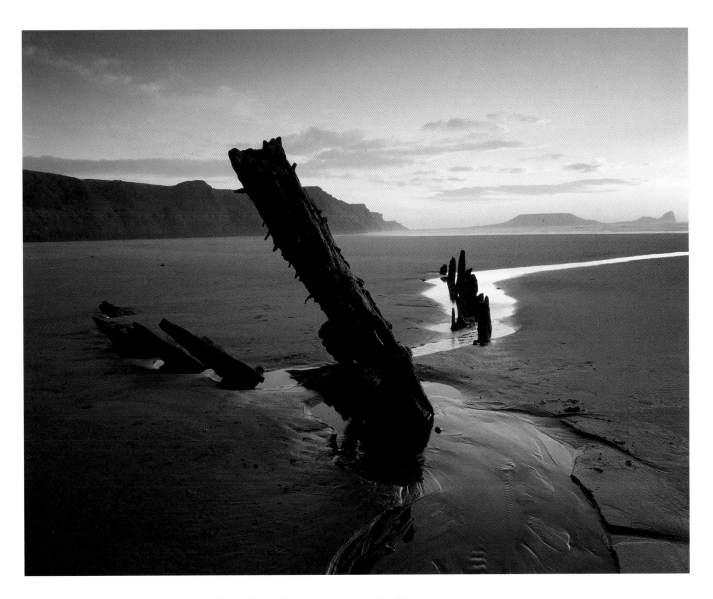

Photographers want viewers of our images to believe that the beauty we represent is 'true' beauty.

There can be no objectivity beyond the gathering and rendering of light because there is no universal definition or measurement applicable to the making or viewing of a photograph. There can, therefore, be no such thing as the 'best picture'. Like cooking, photography is a matter of taste, a matter of relative not absolute value. Meaning in photography, beyond denotation, inhabits a range of values, as it does in all other forms of visual representation. Photographs are never wholly mirrors nor wholly windows: they are more akin to semi-silvered glass upon which a ghostly representation of the photographer's intent is mingled with a reflection of our own concerns and through which we see an incomplete image of the world.

The promotion of technology in photography has led to the commonly held belief that there is some transfer of creative responsibility from the photographer to the equipment.

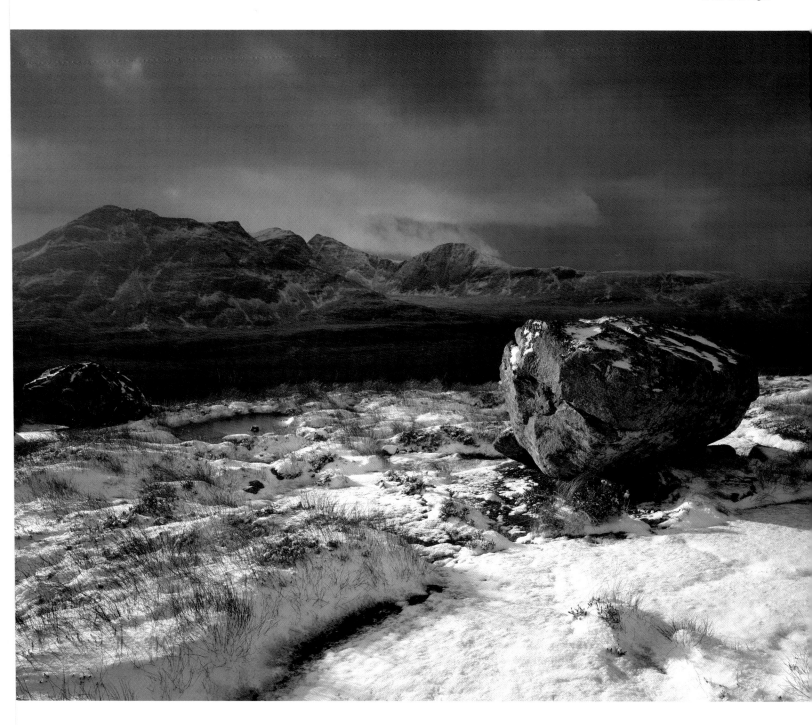

On the surface, photography's subject is the depiction of space. Not the kind that Yuri Gagarin was the first man to enter in 1961, though that too has been the subject of its scrutiny. Rather, I'm referring to the earthbound, air-filled volume that surrounds us; the everyday space through which light travels to our eyes, light that has been reflected from the surfaces of the world around us. As photographers we spend a great deal of time making sure that the arrangement of forms, tones and colours from the scene photographed blend to produce a pleasing composition within the camera's frame. Indeed this complex undertaking seems to be the paramount task of a photographer.

There is another major theme in photography, one inextricably bound to the process of image formation and, if you know where to look, evident in every image we make. Light's equal partner in photography is time; and, as Rebecca Solnit points out in her excellent book *Motion Studies*, time often provides the deepest, frequently unacknowledged, theme of photography. Time and light are the raw ingredients for making a photograph. We might even think of 'cameras [as] clocks for seeing', as Roland Barthes suggested. Whenever we look at a starry sky, as Gagarin no doubt did, we are looking into time. The light reaching us from the sun or other celestial objects has travelled not just through space but also from the past. We have always been able to look back in time by lifting our eyes to the heavens but until photography we were never able to hold time in our hands.

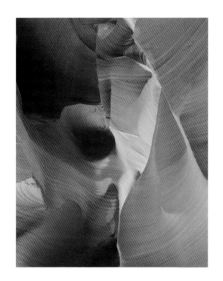

The investment of time is the single most important purchase a photographer can make if they wish to excel at their craft.

The singer Jim Croce lamented that he couldn't 'keep time in a bottle' – but we can! The only problem is that we have to stop it and roll space out flat in order to keep it captive. Time in a photograph remains visible but untouchable; we can look again and again at the river of time but not step into it at the same spot at which the photograph was made. When we look at a photograph we study a portion of time that has a certain past but no future. Time has been arrested in the photograph at the point at which the exposure was made. That slice of time will be carried forward, in stasis, for as long as the image exists; the photograph is, as Barthes suggested, like Sleeping Beauty in her glass casket – except that no handsome prince can awaken the contents of the frame. Each exposure represents a time frame, literally a frame of time, but outside each frame time marches on.

We often say that a photograph is 'taken', that an image is 'captured' on film as if light has been taken hostage, trapped within the prison of the emulsion. Many photographers dislike this description, preferring the verb 'make'. 'Take' is thought pejorative for two reasons: firstly because of its connotations of possession – it's almost as if we accept the aboriginal people's belief that photography abducts an individual's spirit; secondly, it is a lazy word that implies that images are there to be harvested – it seems to dismiss the need for a creative act. Barthes felt that 'take' also implied the intention to shock the audience (to take by surprise) and hence could be rightfully applied to all photographs that were made without the subject's permission, from news to what is repellently called candid photography. (There is little that I find honest in this genre; more often than not it reflects the photographer's prejudices rather than casting a fresh light on the subject.)

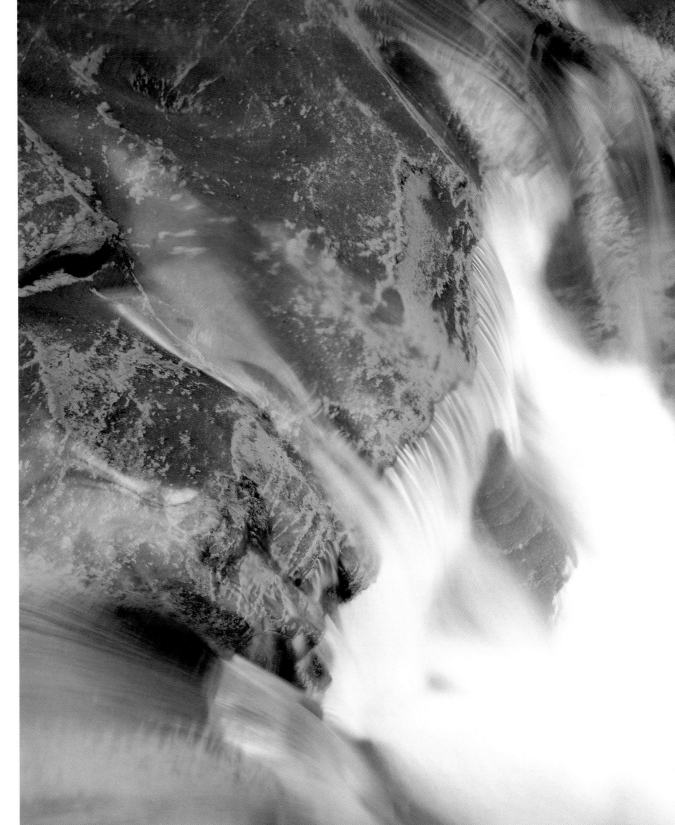

When we make an extended exposure of moving water the resulting image is something our linear perception of time and space could never have envisaged before the invention of photography. What we see are the three dimensions of space mutated by time.

There is a deep misapprehension amongst non-photographers regarding the supposedly facile nature of the photographic process. A comparison is made between time spent on image creation and its intrinsic worth; it is felt that the faster an image is made the less worthy it is of our attention.

'Make' is without doubt the more positive and active term, not least because it strongly implies intention on the part of the photographer. It firmly assigns the responsibility for the creative act to the photographer. However, in one important sense the word 'take' is absolutely correct: when we set a speed and an aperture and open the shutter we take (we abstract or we collect) carefully controlled amounts of light and time, from the enormous oceans of instants and radiance that surround us. This 'taking' is used to produce a document of four dimensions expressed in two. This condensation, this process of compacted transcription, can give rise to a form of vision radically different from how we, as humans, perceive the world. I think it is important to realize that, as well as 'solidifying' light, a photograph fixes a portion of time and binds it to the light which entered the camera during exposure.

In early Daguerreotypes of Parisian streets it seems as if the populace has fled, leaving behind only the photographer to document an empty city. Samuel F. B. Morse, painter and inventor of the eponymous code, was in Paris in 1839 when Daguerre announced his invention. He wrote to friends in New York, 'Objects moving are not impressed. The Boulevard, so constantly filled with a moving throng of pedestrians and carriages, was perfectly solitary, except for an individual who was having his boots brushed.' This illusion arises from the fact that exposures were then measured in minutes rather than seconds or fractions thereof. The darkly moving mass of people left behind no distinct trace because the light reflected from the fixed surfaces of the architecture expunged their latent images long before they could be developed. It is as though the immovable has consumed the mobile, almost as if the buildings have eaten the people. Where some trace of an individual remains, like the man having his boots brushed, it is their immobility – their relative lifelessness – that has saved their image for posterity. Unlike his sedentary client, the shoeshine boy is no more distinct than a wraith. The motion of minutes has been collapsed into the instant of viewing a photographic image, and in that compaction a new kind of reality has been wrought.

The Rephotographic Survey Project, begun by American photographer Mark Klett in the late 1970s, provides an interesting comparative study of time frames. Klett set out to re-photograph sites that had been photographed for the very first time by pioneer photographers like Carleton Watkins and Timothy O'Sullivan in the 1860s and 1870s. He used exactly the same viewpoints and equivalent focal length lenses to duplicate the optical representation of each location. The process has since been repeated again, in the late 1990s, under the auspices of the Third View project. When we look at the three images from any given location it's like a stop-motion animation experiment conducted over almost a century and a half. We are able to witness the changes wrought on the landscape by natural processes and, most obviously, by man. A period of just over a century is just the blink of an eye in geological time. Consequently, the rocks and hills appear unchanged, except for signs of mankind's handiwork, whereas the vegetation, the living fabric which clothes the structure, is shown to be much more dynamic. When Eadweard Muybridge took his original shot from Moonlight Rock in the Yosemite Valley in 1872, a vista of El Capitan and the gates of the valley opened before him. Yet, when Mark Klett returned to this spot, a century later, vegetation had almost completely crowded out the view. It is these living changes in the landscape that I find most striking. We know intellectually that the vegetation changes but unless a landscape

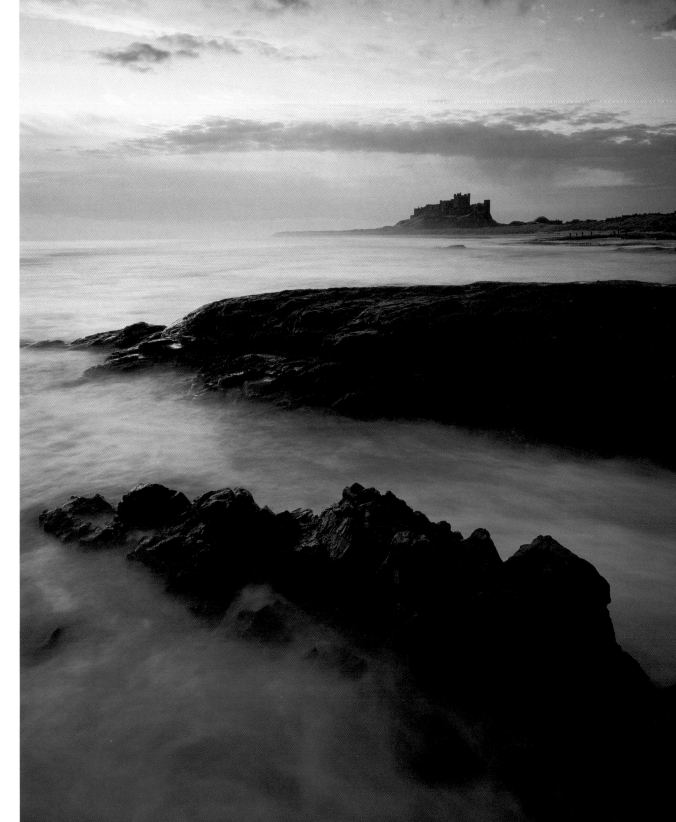

When we set a speed and an aperture and open the shutter we take carefully controlled amounts of light and time, from the enormous oceans of instants and radiance that surround us.

In long exposures the motion of minutes has been collapsed into the instant of viewing a photographic image, and in that compaction a new kind of reality has been wrought.

Written histories are only words if they lack the corroboration of physical evidence; but a photograph is an eyewitness,
it shows us the truth of when and where it was made.

is familiar to us over a lifetime these changes often go unnoticed or unremarked. In contrast the gross changes such as the drowning of a valley by a hydroelectric scheme (as at Feather River, Oroville, California, originally photographed by Carleton Watkins) are somehow less revelatory and more wearily expected. Photographic documentation admits us to a reality beyond a mere human lifespan.

According to Roland Barthes, in *Camera Lucida*, before the invention of photography there was no certainty in history beyond the artefacts and buildings that have survived the journey to the present. Written histories are only words if they lack the corroboration of physical evidence; but a photograph is an eyewitness, it shows us the truth of when and where it was made. Barthes opined, 'we have an invincible resistance to believing in the past, in History, except in the form of myth. The photograph … puts an end to this resistance: henceforth the past is as certain as the present.' He illustrates this point by describing a photograph he had cut out of a magazine which showed a slave market in all its terrible and yet banal reality. 'I repeat', he exclaimed, 'a photograph, not a drawing or engraving; for my horror and fascination as a child came from this: that there was a certainty that such a thing had existed.' For Barthes this and all other photographs represented irrefutable evidence more powerful than any written history.

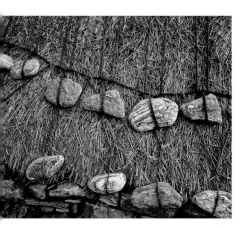

Beyond the wider social history, photography has fundamentally changed the personal history of each and every one of us, in a deep and radical way whose only parallel was the invention of writing. Before writing there was no way to reliably record and fix our thoughts and our personal insights. Merely speaking them is not a dependable means of dissemination. There is a scene in the Monty Python film *The Life of Brian* in which the viewer eavesdrops on a group at the edge of the crowd attending the Sermon on the Mount. Jesus' pronouncements have subtly mutated by the time they reach these outliers so that his original wise words have become something bizarre: 'the Greek shall inherit the Earth' and 'Blessed are the cheese makers.' Any conversation can be thought of as the beginning of a giant game of Chinese whispers where thoughts released from our mind via the spoken word are liable to evolution and embellishment. In contrast, the written word serves as an anchorage to thought; text is a fixed point of return where notions can be verified against the original.

Elliot Erwitt once said, 'if it hasn't been photographed it doesn't really exist'.

Now, try to imagine a world without the family photo album. Human memories are just as susceptible to embellishment as our words. In the same way that our ideas are fixed by written documents, so our memories of events in our personal lives are now very often defined by accompanying photographs. Elliot Erwit once said, 'weddings are orchestrated about the photographers taking the picture, because if it hasn't been photographed it doesn't really exist'. The twenty-first birthday party, the graduation ceremony, the holiday, the christening and countless other less significant moments are entrusted to the permanent vault of photographic representation for safekeeping. The image may fade, the colours may change but there is still an air of irrefutability about the photograph that dominates our personal histories. If you can't remember what great-aunt Dorothy looked like, what colour hat she was wearing – just reach for the photo album! Memories of the faces of our social circle and events in which they participated

are as much the memory of the photographic evidence as of reality. The time of our lives is imprinted on photographic paper: we might almost intone 'In Kodak we trust.'

Whilst time is evident in every exposure, it often closely corresponds to our own perception, so closely in fact that we ignore its presence. If, however, we make an exposure of extremely long, or short, duration, the image produced steps outside the boundaries of how we see the world. When we make an extended exposure of moving water the resulting image is something our linear perception of time and space could never have envisaged before the invention of photography. Solnit quotes the cinematographer Hollis Frampton, who, writing about Eadweard Muybridge's photographs of waterfalls in Yosemite, suggested that long exposures 'produce images of a strange ghostly substance that is in fact the tesseract of water: what is to be seen is not the water itself, but the virtual volume it occupies during the whole time-interval of the exposure'. A tesseract is a geometric representation of a cube in four physical dimensions so that a tesseract is to a cube what a cube is to a square and what a square is to a single line. Frampton has it right in the second half of this statement but a tesseract is not quite the right allusion. We are seeing four dimensions but only three of them are physical; what we see are the three dimensions of space mutated by time.

Many people see these long exposures of waterfalls as unrealistic and hackneyed. Personally, provided the overall composition is satisfactory, I like the magic wrought by long exposures precisely because this vision represents a new reality, something uniquely photographic. What's unsettling is not the blur per se (we perceive falling water as blurred unless we consciously track its path with our eyes), rather it is the accumulation of blur, the stacking up of one blurred image upon another in a continuous flow. Our perception of any object moving above a crawling pace may be likened to the individual frames of a movie or video sequence; if you study each frame of a video the images are blurred but when the sequence is run they appear sharp. This sharpness rests on the point of focus rather than a complete freezing of motion. As one image dissolves seamlessly into another, the motion blur is subsumed below the apparent sharpness arising from the position of the plane of focus. But, in the extended accumulation of blur resulting from exposures of several seconds, both focus and, often, the direction of motion have been lost.

It is not just long exposures that step outside the bounds of human perception. If you make an image with a very short shutter speed, so as to freeze rapid motion, you also go beyond what is discernible with our own eyes. No human eye can freeze the motion of a hummingbird's wings unaided, yet the camera can. It was Eadweard Muybridge who first demonstrated photography's ability to reveal the secrets of motion. In the spring of 1872 he photographed a trotting horse called Occident that belonged to Leland Stanford, one of the four great US railway tycoons. The single grainy, not very sharp, photograph froze, for the first time on film, the motion of a horse's legs.

Stanford, president of the Central Pacific Railroad, was one of the men who were instrumental in bringing the Iron Horse across America but he also had a passion for flesh and blood horses. This passion was made evident by the large proportion of his vast wealth spent building a stable of

Landscape photographs recall and relate a connection to the cycles of the world that we have lost touch with amidst man-made schedules and the pollution of artificial light.

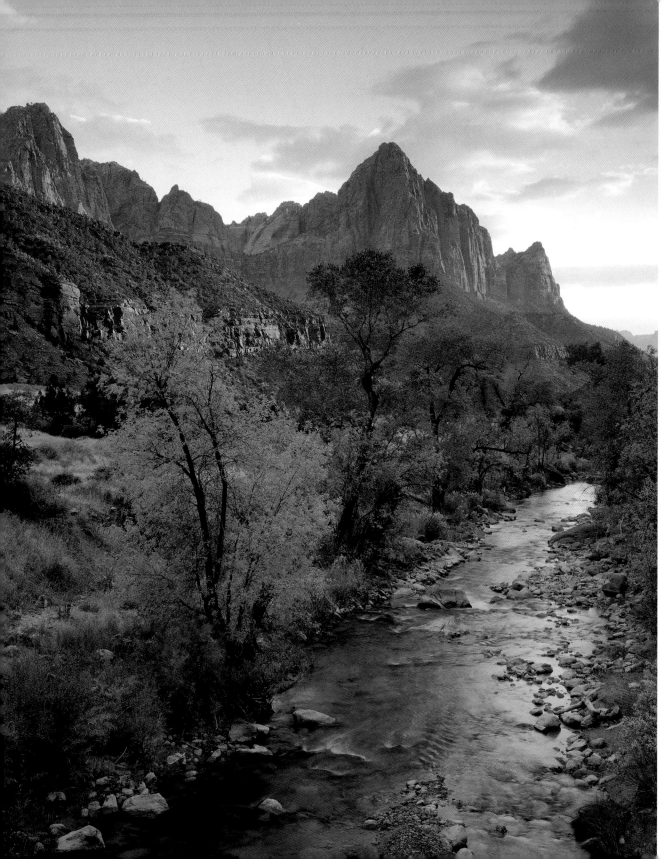

Landscape photographs relate to time at a number of levels: they speak of the daily cycle of light; they speak of the longer cycle of the seasons; they speak also, especially to the town and city dweller, of a slower pace of time than the everyday struggle of work.

the best trotting horses in the US at his ranch in Palo Alto, California. Painters and horse fanciers had argued for centuries over the exact sequence and position of a horse's legs during the gallop. Stanford determined to solve once and for all the riddle of the horse's gait. The unaided eye cannot resolve this motion but Stanford lit upon the idea of employing Muybridge and using photography to solve the conundrum. The experiments that Muybridge began in 1872 would eventually lead to the birth of the cinema. Along the way he would solve problems in chemistry (to allow the instantaneous rendering of an image) and build the first camera shutter and the first device for remotely triggering a camera. Muybridge progressed from single images to series (using banks of cameras), and from studies of the motion of a horse to somersaulting humans. In so doing, as Rebecca Solnit writes, 'He had captured aspects of motion whose speed had made them as invisible as the moons of Jupiter before the telescope.'

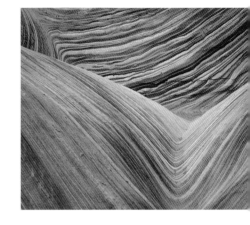

In landscape photography it is the graphic elements that immediately dominate our reading of the image. Yet we are often drawn to this genre because the depictions of these forms evoke emotional responses linked to time. Landscape photographs relate to time at a number of levels and often many simultaneously within a single image: they speak of the daily cycle of light, of the changing length of shadows, of the changing angle of light, of the cold light of midday and the warm light at sunrise and sunset; they speak of the longer cycle of the seasons, the monochromatic trees and snows of winter, the fresh greens of spring, the russet tones of autumn; they speak also, especially to the town and city dweller, of a slower pace of time than the everyday struggle of work, of lazy Sunday afternoon walks, of holidays in the hills and by the coast. They recall and relate a connection to the cycles of the world that we have lost touch with amidst man-made schedules and the pollution of artificial light.

A century and a half ago, around the time photography was invented, the tempo of human life for the vast majority of Europeans was still linked to diurnal and seasonal rhythms, as it had been since humans first came down from the trees. Most people arose before the dawn, worked upon the land according to the demands of the season and returned to their beds not long after sunset. The speed at which they worked was constrained by the limitations of their own physique and the natural strength and speed of the beasts they employed. But there was an incipient quickening of tempo that would affect the majority of Europeans and especially their cousins who were settling North America; the Industrial Revolution was burgeoning. We, in the West, would soon all have to march in step with machine time.

Strangely, although photographs always speak of time, what we often admire most in a landscape photograph is timelessness. We like to imagine that the image was made in some indeterminate pre-industrial age, ideally a place of Edenic innocence and beauty. Yet for a long time landscape as a topic for painting was shunned – ironically in part because our 'fall from grace', our expulsion from the Garden of Eden, seemed inherent in the subject. When landscape eventually became a subject for painting the landscapes depicted were settled and subjugated. Not man at ease with nature as much as man the conqueror of nature; not nature red in tooth and claw but nature with her teeth pulled and her claws severed. But, since Ansel Adams and his

Strangely, although photographs always speak of time, what we often admire most in a landscape photograph is timelessness.

contemporaries in the f64 group, nature in landscape photographs is more often depicted imagined as uninhabited, as pristine. We now aspire to give our landscapes the look of an age before cars, before factories and definitely before pylons. We seek to cut the image loose from our present by minimizing or, preferably, excluding the visual anchors which tie it to the here and now.

It is our nostalgia for this slower pace of time, more than a simple wish to banish modernity, which leads us to exclude certain objects from the frame. Objects are included or excluded according to their affiliation to a particular era and/or their state of decay. So, a dry-stone wall or rotting driftwood or rusted machinery might be included whereas a galvanized chain-link fence or plywood or a shiny new Ford might not. Rather than being honest with ourselves we tend to justify these exclusions on aesthetic terms. We say that telegraph poles are ugly (though it is perfectly possible to make striking, rhythmical compositions which include them), or that contrails spoil the sky (though they sometimes differ little from cirrus). But what we really feel is that these signs give the game away; they wreck the carefully constructed fiction that the image is of some indeterminate, unspoilt and relaxed 'whenever'. They force us to realize that it is of the inhabited, imperfect, despoiled and hurried present.

So when we look at the image of Bamburgh Castle (see page 000), we see time as much as light; we see the ancient rock outcrops of the Whin Sill, we see the seemingly immutable castle, we see the tranquillity of an autumn dawn and, finally, we see the unstable passage of waves spilling around the granite, rendered as an ethereal permanence. Trapped within the film emulsion, in this single photograph, we have a representation of geological time, historical time, seasonal time, diurnal time and the passage of just eight seconds. All photographs, no matter how brief the opening of the shutter, are time exposures.

Photographs also communicate to us of the time spent by the photographer: time spent on the journey to the point at which the image was made in order to choose the significant moment. This spending of time is not simple expenditure for short-term gain but rather a long-term investment by the photographer. The investment of time is the single most important purchase a photographer can make if they wish to excel at their craft. A photographer must invest time in order to learn the mechanics of the craft but also, more importantly, in order to learn how to see. Roland Barthes wrote in *Camera Lucida* that one of the five 'surprises', or key elements, of photographic practice is the '"natural" scene which the good reporter has had the genius, i.e., the luck, to catch'. We've all heard photographers describe fellow photographers as lucky, and indeed we've all probably applied this description to ourselves. The great golfer Gary Player, after making an incredibly difficult shot, was once told by a fellow player that he was lucky, to which he replied, 'The funny thing is, the more I practise the luckier I get.' Capturing a photograph can sometimes be just dumb luck, but making an image requires persistence, experience and skill, often acquired over many years of dedicated application.

Persistence, as in any other field, is the key to success in photography. Persistence in landscape photography isn't measured just in minutes or days but more likely in weeks, months or

Time in a photograph remains visible but untouchable; we can look again and again at the river of time but not step into it at the same spot at which the photograph was made.

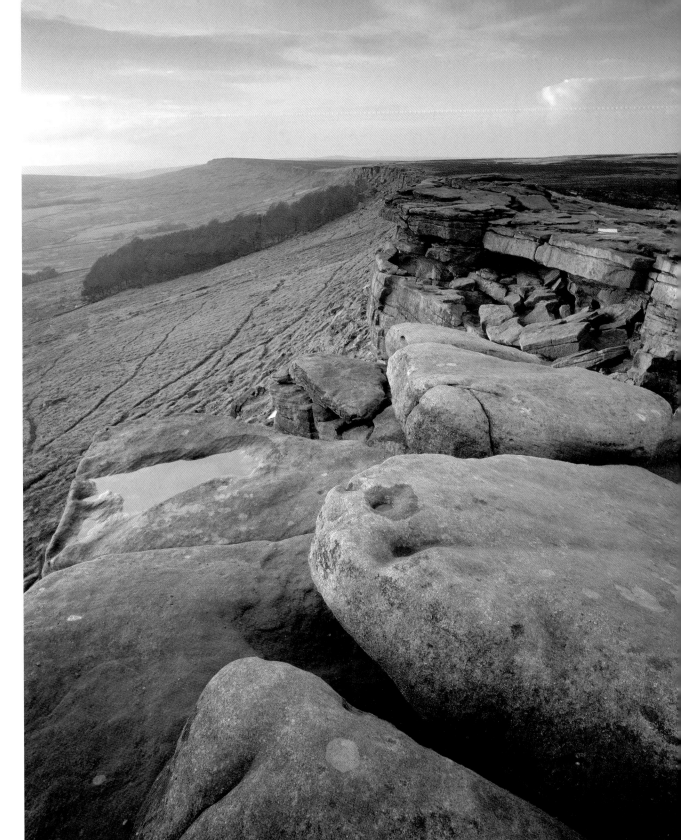

Memories are as much the memory of the photographic evidence as of reality. The time of our lives is imprinted on photographic paper: we might almost intone, 'In Kodak we trust.'

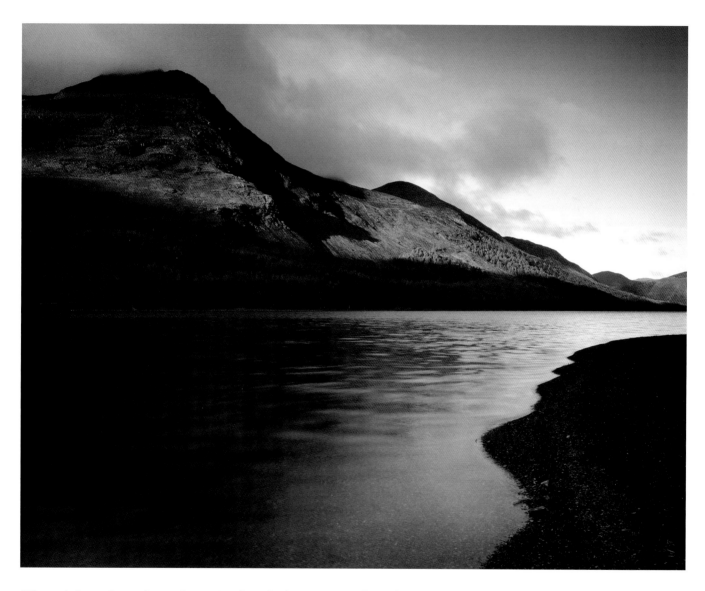

When we look at a photograph we study a portion of time that has a certain past but no future.

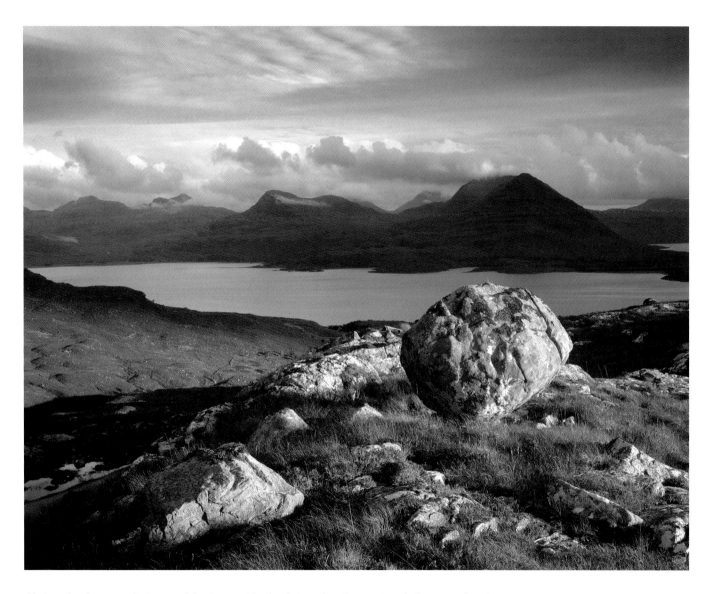

Photographs also communicate to us of the time spent by the photographer: time spent on the journey to the point at which the image was made.

even years. I have lost count of how many times I have revisited locations in a particular season in order to make the photograph I had envisaged. Often, at the time, it has seemed a futile process. I've questioned, 'Why am I going there again?!' But my experience is that persistence always pays off, sometimes with an image far more interesting than that I originally sought.

There is a deep misapprehension amongst non-photographers regarding the supposedly facile nature of the photographic process. At the heart of this is a comparison between time spent on image creation and its intrinsic worth; it is felt that the faster an image is made the less worthy it is of our attention. The exposure time of a photograph is equated with the gestation of the image, but except in the case of a grab shot no such equation is justifiable (and, arguably, not even then).

A work by an Old Master undoubtedly has additional value attached to it (above the aesthetic and creative) resulting from the time invested in its creation. But to draw the shallow corollary that a photograph is created in moments and therefore cannot be art is a fundamental misunderstanding of the creative process in the visual arts. The true gestation period of a photograph is not the seconds, or fractions of seconds, of the exposure but rather the years the photographer has spent on a journey that is both physical and intellectual before reaching the point when the shutter was opened.

The true gestation period of a photograph is not the seconds, or fractions of seconds, of the exposure but rather the years the photographer has spent on a journey that is both physical and intellectual before reaching the point when the shutter was opened.

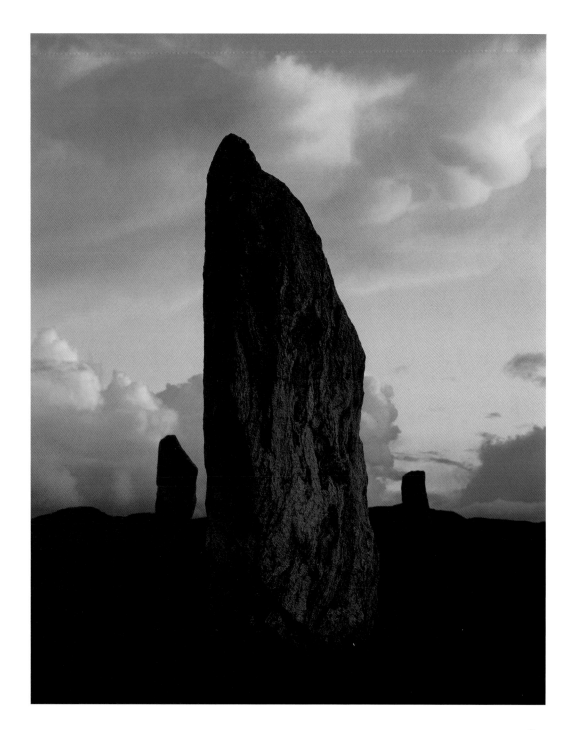

Representations of the vista in photography are still largely bound to the landscape traditions that arose in painting in the seventeenth and eighteenth centuries.

3

Worlds within Worlds

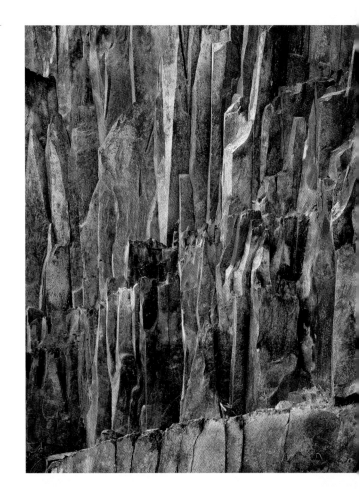

Differing approaches to landscape imagery

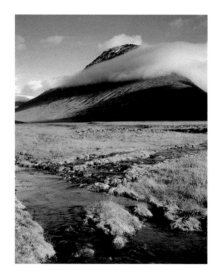

Our current positive attitudes toward wild, windswept and craggy mountains arose with the Romantic movement in art.

The vista is often seen as the height of achievement in landscape photography, following a tradition firmly established by Ansel Adams and other members of the f64 group at the turn of the last century. The vista: wide-open spaces, lush farmland perhaps, a meandering river, beautifully framed by beguiling hills and verdant forests. It seems so easy and so natural to start with the wide view, but reaching for the supposed pinnacle of landscape imagery requires as much effort as attaining a physical summit. Despite this it is the subject that most photographers choose when they first make landscape images – probably because when we think of the landscape what we visualize is often a vista. In fact landscape and vista are almost interchangeable terms in most people's minds. There is evidence to suggest that wide views appeal so strongly to us because they correspond to the savannah environment in which we evolved and that the response is to some degree genetically coded. We like wide-open spaces with freedom to roam and freedom from being ambushed by predators because that's how we spent our formative years as a species.

But for the photographer, there are numerous practical problems to overcome when striving to represent a vista; finding a suitable location, the quality of light, lens restrictions, difficulties of composition (unwanted humans in brightly coloured jackets, inappropriate animals, clouds in the wrong place). In fact I think that making a successful photographic vista is more difficult than almost any other kind of landscape image. Consider Ansel Adams, a master of his art. He made photographs throughout seven decades in Yosemite (a place that many consider to be the most exceptional landscape on earth) yet he made only a few dozen well-known vistas. Why? Simply, because it is so difficult to make a good vista! Novice photographers can be disheartened by these difficulties. Adams himself wrote, in a wider context, 'Landscape photography is the supreme test of the photographer – and often the supreme disappointment.' Novices do not realize that what they are trying to do is the equivalent of scaling the highest cliff unaided at a time when they should still be practising their basic rope work. In fact, frustratingly and all too often, the conclusion reached after a few attempts is, 'It's not a patch on that shot Ansel took here, so I won't bother.'

Even before Adams, the vista was king, a position it inherited from western traditions in painting stretching back to the landscape works of great seventeenth-century artists such as Claude Lorraine and Nicholas Poussin. Representations of the vista in photography are still largely bound to the landscape traditions that arose in painting in the seventeenth and eighteenth centuries. Landscape in western art graduated from backdrop to subject around the beginning of the seventeenth century. The word entered the English language in this period as 'landskip' from the Dutch word 'landschap'. The northern European tradition of landscape painting, epitomized by the Dutch, was naturalistic and celebratory in a secular, even nationalistic manner (Holland having just gained independence from Spain). In contrast the landscapes of Poussin and Lorraine, from southern Europe, were grand, idealized and dramatic arrangements which were still employed as backgrounds for mythological or religious figures. Whatever the stylistic approach taken, both Dutch and

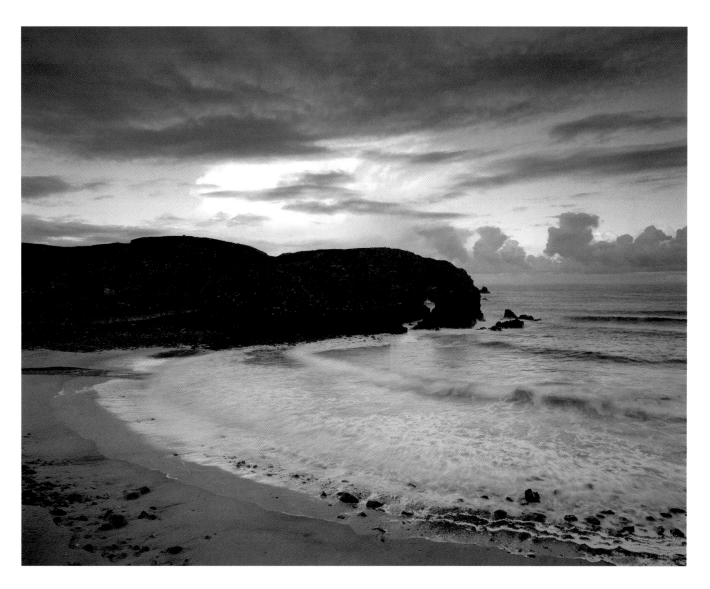

It seems so easy and so natural to start with the wide view, but reaching for the supposed
pinnacle of landscape imagery requires as much effort as attaining a physical summit.

Italian artists concentrated on the wide view, the vista. It was not until late in the nineteenth century that smaller-scale views became commonplace.

I believe art should be about self-expression. More than that it should be seductive, it should engage us on a sensual as well as a cerebral level.

In the eighteenth century numerous well-to-do English men and women took the grand tour of Europe to broaden their social, cultural and artistic horizons. They were inspired by the allegorically constructed, imaginary landscapes of Poussin and Lorraine that they encountered on their travels. They sought equally dramatic viewpoints on their return to Britain. What they thought of as dramatic we would be much more likely to describe as picturesque; a word that is, more often than not, thought synonymous with pretty or pleasing but actually, simply, means worthy of capture as a picture.

Our current positive attitudes toward wild, windswept and craggy mountains arose with the Romantic movement in art, beginning in the late eighteenth and continuing throughout the nineteenth century. Romanticism emphasized an artist's emotional sensibility above intellectual reasoning – though ironically there was no shortage of theorizing as to what constituted good Romantic art. The artist's task was seen as conveying feeling for the subject, as portraying beauty and the sublime, and their offspring the picturesque. To a Romantic artist the word picturesque had a much deeper resonance than it has today. The defining characteristic of the picturesque was a concentration on ruggedness in form and texture, something which still fascinates photographers. The influential art critic and theorist Revd William Gilpin wrote, 'Roughness forms the essential point of difference between the beautiful and the picturesque.' A study of the beauty of the natural world was central to Romanticism, but importantly beauty was seen as dependent upon certain compositional criteria being fulfilled: nature was only truly beautiful when you could fit its elements neatly in a frame (they weren't above subtle manipulation of perspective and content to achieve this).

The setting of the works of man amidst nature was also seen as picturesque, and most powerfully when those works were in a state of decay. Gilpin wrote, in *Three Essays on Picturesque Beauty* (1794), '… the picturesque eye is perhaps most inquisitive after the elegant relics of ancient architecture; the ruined tower, the Gothic arch, the remains of castles, and abbeys. These are the richest legacies of art. They are consecrated by time: and almost deserve the veneration we pay to the works of nature itself.' The nineteenth-century painter, writer and philosopher John Ruskin saw this aesthetic fascination with ruined buildings as quintessentially picturesque because it conferred 'elements of sublimity … generally … found only in noble natural objects' on man-made artefacts. The more decayed a ruin became, the closer it approached a natural state, the more beautiful it became. He also noted, though, that these elements were generally 'somewhat detrimental to it as a cottage or mill'!

A rough, hilly or mountainous landscape was thought picturesque then, as now, but this didn't just reflect a new-found fascination with particular forms, it also indicated a shift in attitude. Wilderness had been thought terrible rather than beautiful. Wild, wilder, wilderness – these are loose, lax, almost promiscuous words; words that freely associate with a huge range of

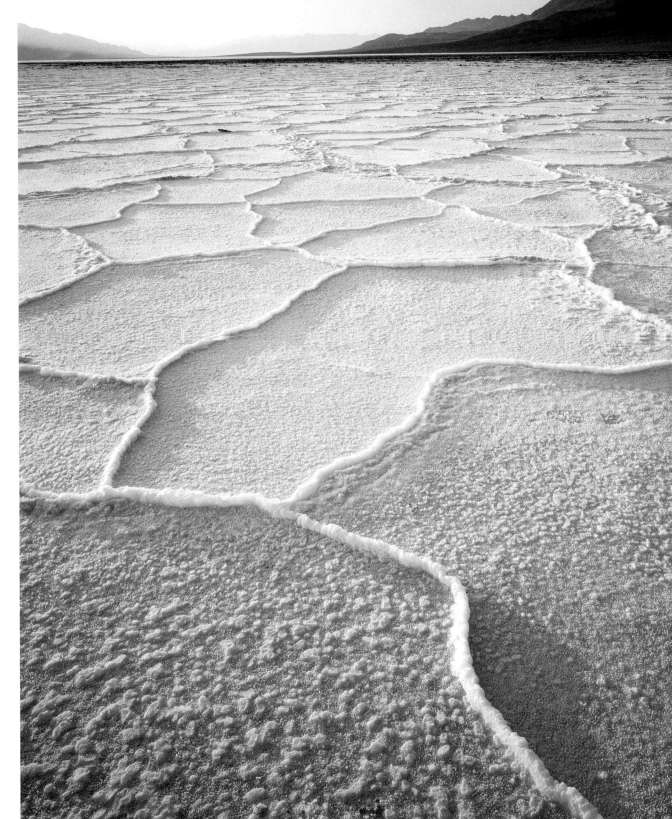

*There are
numerous
practical
problems to
overcome when
striving to
represent a
vista: finding a
suitable
location, the
quality of light,
lens
restrictions,
difficulties of
composition.*

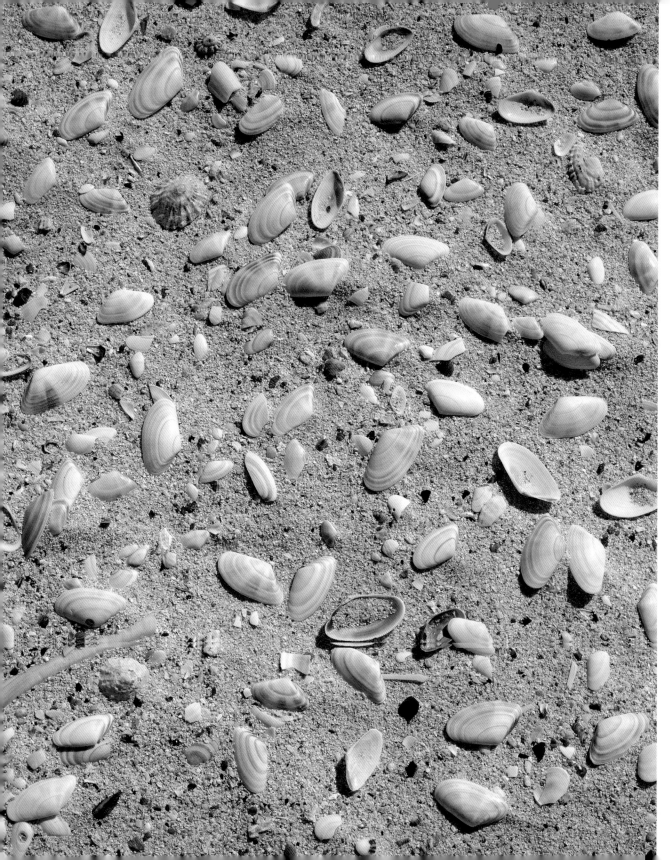

An aesthetic appreciation of your environment demands a full stomach and the leisure time to stand back and admire. Neither of these are great evils but they may be signs of a degree of separation from your surroundings.

meanings, some almost diametrically opposed to others. This range reflects a migration in meaning over the last couple of centuries, yet their original definitions are still in use. Wild once most strongly connoted untamed, fierce, savage, godforsaken or uncultivated. In the Old Testament there are six Hebrew words that have been translated into English as wilderness; their literal meanings are 'a desolation', 'a worthless thing', 'a sterile valley', 'an arid region', 'a haunt of wild animals' and 'an open field'. It's probably safe to say that wilderness, then, was thought of as not only useless but ugly.

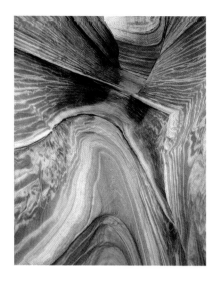

However, wild is now more likely to be coupled with exciting, pristine, unsullied, untampered with, intact or virgin. And now the wild is something beautiful to be conserved. This breadth of connotation has imbued notions of the wild with an incredible power for conflicting political groups. There's even a worrying overtone of aggressive sexuality in the meanings; depending upon your point of view you might have visions of man raping the virgin land or the land simply asking for defloration.

Just what kind of word is it whose definitions can encompass 'untamed' and 'virgin', and how did it change from a negative term to a positive one? The change in emphasis mirrors mankind's changing relationship with the natural world. A couple of centuries ago, when the vast majority of humanity lived a rural existence, it was hard to spare the time and energy from the everyday work of survival to become sentimental about the landscape. Tellingly, the original Persian concept of Paradise is not nature in the raw but nature tamed, nature sanitized: a garden. An aesthetic appreciation of your environment demands a full stomach and the leisure time to stand back and admire. Neither of these are great evils but they may be signs of a degree of separation from your surroundings. A common saying from the Scottish highlands, 'You can't eat the view!' nicely sums up the gulf between living off the land and simply admiring it. The move away from subsistence can give rise to a degree of idealization, a sense of nostalgia for a lost bucolic idyll.

Many of today's landscape photographers still seek to portray the landscape within this Romantic framework. Those earlier Romantics would have felt totally at home with Michael Fatali's quasi-religious musings on photography as well as his celebratory landscape images, which portray the world as the sublime handiwork of the creator. Though Adams always professed himself a modernist, because of his straight approach, both he and Fatali are heirs to the Romantic tradition. I disagree with the American photographic writer Mike Johnston when he professes that Adams was 'reacting against pictorialism, [but] he is just as much the last of the nineteenth-century survey photographers, the culmination of the aesthetic apotheosis of Jackson and Watkins et al'.

In John Szarkowski's terms the survey photographers were producers of windows, documentarians, whereas Adams was very definitely a man who made photographs that were mirrors, art which reflected him and his vision. This is spiritually far closer to the Romantic ideal than to documentary. I see no reason for this statement to be thought pejorative because I

Wilderness was once thought terrible rather than beautiful. Wilderness is now more likely to be coupled with exciting, pristine, unsullied, untampered with, intact or virgin.

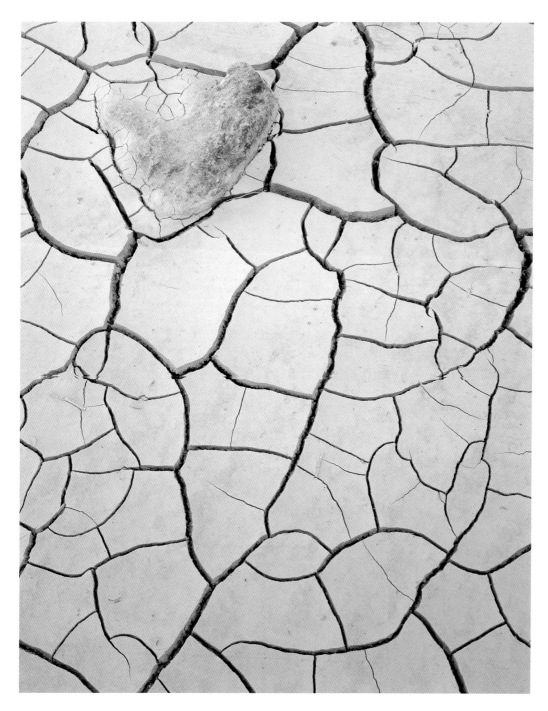

A great
photograph is a
distillation, a
reduction of the
chaos of our wider
experience to a
visually satisfying
essence where
what is excluded
is as important
as what is
included.

believe art should be about self-expression. More than that it should be seductive, it should engage us on a sensual as well as a cerebral level. Our eyes should be able to feast upon art; it should be sumptuous. A great deal of modern art has turned its back on visual richness and concentrated on being coolly intellectual instead. The problem with this, I find, is that the period of engagement with a piece is so short-lived. Once you've 'got' a Damien Hirst piece there is nothing left for your senses, no craft to appreciate, there is little depth or sense of wonder. In contrast, a photographer like Michael Fatali sets out to portray the landscape at its most seductive and exuberant and in the process provides a visually opulent and rewarding experience for the viewer.

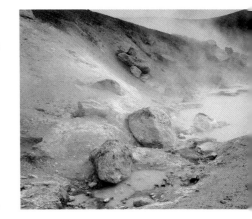

The human mind craves a certain level of organization in an image; composition springs from this desire for the representation of form (somewhere between the oppressive restriction of man-made rectilinear forms and the visually chaotic shambles of dense jungle), in order that our minds may make visual sense of an image. Yet the wider world is essentially complex and chaotic, much of it inimical to representation as the vista. The Swiss philosopher Henri Frederic Amiel proclaimed, 'The great artist is the simplifier.' A successful photograph, be it a vista or on any other scale, exudes this simplification. Such an image is a distillation, a reduction of the chaos of our wider experience to an easily digested and visually satisfying essence where what is excluded is as important as what is included. The process for achieving this paradigm is sometimes referred to by the facetious acronym KISS – Keep It Simple Stupid. On a more plaintive note, Vincent Van Gogh wrote to Paul Gauguin, in one of the last letters of his life, 'How difficult it is to be simple!' The author Mark Hertsgaard notes, 'he was identifying a challenge common to artists down through the ages. To create a work of art that is simple yet still beautiful and compelling is indeed difficult, for it means expressing the core essence of reality, uncluttered by what is superficial and secondary. The reward for success, however, is a creation all the more powerful, not to mention accessible, because of its very purity.' It is the complexity of the task of trying to reconcile all the conflicting factors that makes it so hard to produce good vistas. It is easier to achieve simplicity with fewer variables – so why not concentrate on the small world rather than struggle with the larger view?

The vista is fundamentally defined by the horizon. The horizon places us on the surface of the globe beneath the arc of sky.

Here, we are following in the footsteps of giants such as Edward Weston. Originally a commercial Pictorialist portrait photographer, Weston grew increasingly unhappy with a stylistic approach that he felt misrepresented his subjects. Starting with his images of the Armco steelworks in Ohio in 1922, Weston rejected his early work (indeed he later destroyed all his Pictorialist negatives) and pursued a lifelong exploration of form and abstraction. Though famous in later life for his wider landscapes, he spent much of the 1920s and 1930s exploring more intimate subjects. Nautilus shells, peppers, cabbages and the human nude all provided him with rich source material for images that are investigations of the underlying forms of nature. His images are almost a blend of the modernist tradition with the Dutch school of still life. These seventeenth-century studies of flowers, fruit or dead game awaiting preparation and consumption are perhaps the nearest equivalent in European representational painting to Weston's still lives, because of their concentration on texture and detail. But they lack the

57

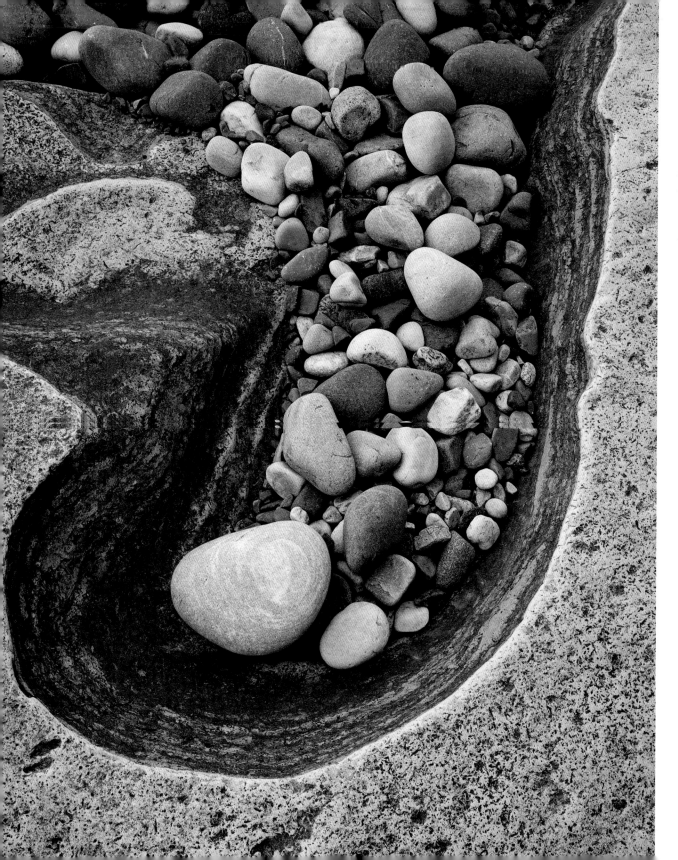

'The great artist is the simplifier.' Henri Frederic Amiel

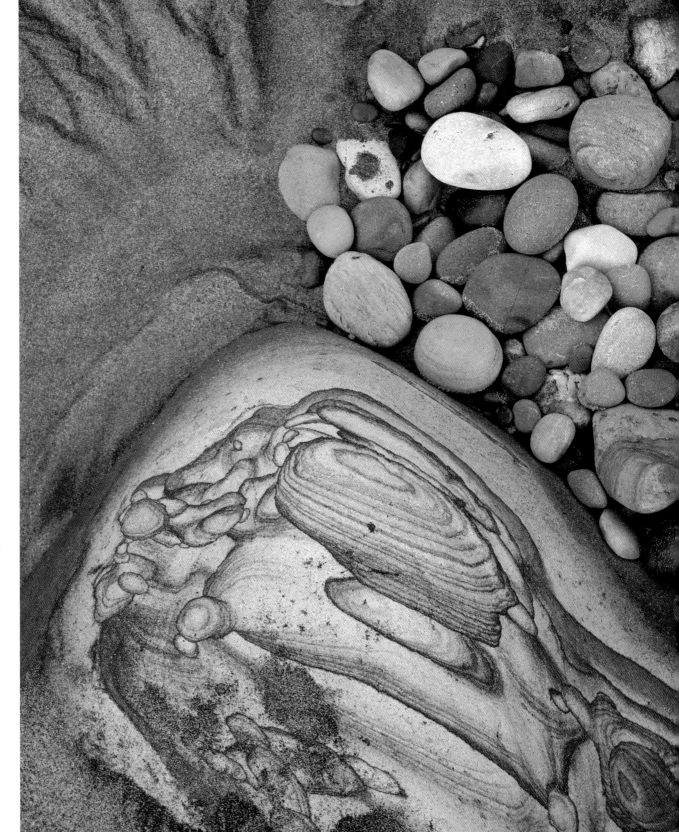

The one constant defining feature of these intimate landscapes is the lack of a horizon.

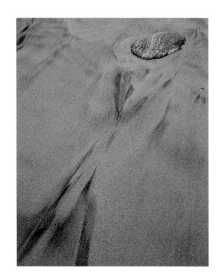

The inclusion of the horizon within the frame is a denial of intimacy; it is the ultimate expression of open spaces, of distance and also of separation.

emphasis on structure and abstraction that Weston's modernism brings. It was through an understanding gained from this abstract work that he later felt able to explore the vista. This raises the question of whether many photographers are not too ambitious in concentrating on the wider view and eschewing a study of the intimate.

So let's turn our back on the vista for a moment and explore the small view, not macro photography, but the intimate landscape at your feet. It's all around us, yet frequently ignored. The most interesting photographic subjects are usually found a little off the beaten track, and so it is within the genre of landscape images.

Let's first define this intimate space: the scale is variable, ranging from a fraction of a metre across to tens of metres. The one constant defining feature of these intimate landscapes is the lack of a horizon. The scale of the vista is the scale of the entire visible landscape. Not the geological or geographical definitions of a landscape that might stretch for hundreds of miles, but that portion of it which lies within view. The vista is fundamentally defined by the horizon. The horizon places us on the surface of the globe beneath the arc of sky. The inclusion of the horizon within the frame is a denial of intimacy; it is the ultimate expression of open spaces, of distance and also of separation.

Photographing the intimate landscape has several consequences.

When we focus on the medium ground it quickly becomes apparent that there is a wealth of form, leading to a much wider choice of subjects becoming available at a higher density. When we seek a satisfying composition we are merely seeking to arrange the available forms in an agreeable way, in balance within the frame. Self-evidently, the larger these forms are, the greater the distances a photographer needs to move in order to effect a change in their arrangement or to introduce new forms.

The world between horizons so often fails to conform to the 'rules of composition'. This leads to a concentration of photography of vistas in a limited number of locations whose geographical formations favour such a wide view; places like Bryce Canyon, Yosemite or Glen Coe in the Scottish Highlands. The intimate view does not suffer from this restriction to the same degree and there is the added bonus that, unlike the majority of vistas, these subjects are usually unknown to a wider audience. The chances of a photographer producing an image that is unique to them are consequently far higher.

Secondly, intimacy implies a certain feeling of being enclosed but does not deny the existence of the wider world. A vista is always, to some extent, an open composition – no matter how artfully overlapping shapes, meandering rivers and converging lines are used to draw the viewer in to the image. But the intimate view can allude to a wider world contingent with, reliant upon, the contents of the frame. This is a more powerfully directed reading than the vista is capable of. These images represent worlds within worlds; they constrain interpretation and

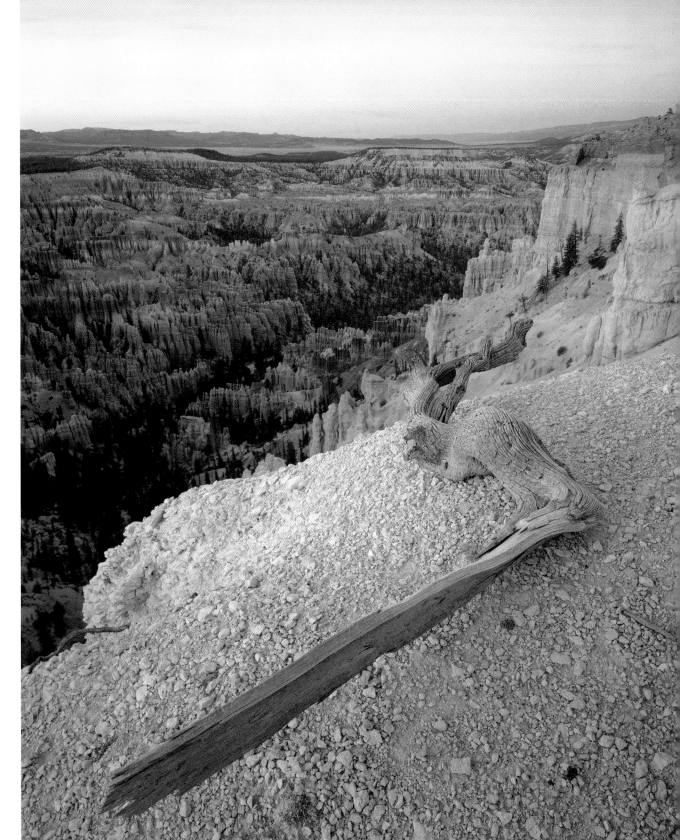

Photographing the intimate landscape increases the chances of a photographer producing an image that is unique to them.

forcefully express the notion of self-similarity. This idea has a long tradition in Western thought, epitomised by William Blake's famous lines:

To see a world in a grain of sand
And a heaven in a wild flower
Hold infinity in the palm of your hand
And eternity in an hour.

Careful choice of content and framing can lead the viewer to construct an imagined world surrounding the selection in the frame. This allusion can be a powerful tool. More than other forms of landscape images, the intimate view presents its own internal logic, forcing the viewer to concentrate on the contents of the frame.

One of the strongest feelings a landscape photographer can convey is a sense of solitude. The photographer can create the illusion of the viewer discovering a space alone; they can present their vision as a revelation in the sole possession of the viewer. The photograph allows the viewer to temporarily inhabit the visual field of the camera and, by extension, that of the photographer. Their vision becomes ours and we benefit from their imagination and insight in a very personal and singular fashion, never more so than within these intimate landscapes.

Thirdly, and finally, the intimate approach helps to move the image beyond the illustrative into the abstract. For photographers seeking to escape from the medium's seemingly oppressive objectivity, abstraction offers the chance for subjectivity to gain the upper hand. The art of photography is essentially about abstraction, as I noted earlier, both in the sense of an extraction of information and the modernist sense of concentration on form, geometry and light. Abstraction can lead to the viewer looking more deeply at a subject than they would otherwise. As a child, I remember being fascinated by those picture puzzles, of the 'What is this?' variety, that showed an everyday object in extreme close-up. My interest hadn't simply been piqued by the quest to solve the puzzle; I was fascinated by the simplicity in the image – there was something about abstraction itself that was alluring.

The great American photographer Minor White recognized that abstraction was an important route to Stieglitz's notion of Equivalence and recorded his thoughts in this crucial passage:

'When the subject matter is rendered in such a way that it is obscure, ambiguous, or impossible to identify, the response to the image takes on a completely different aspect. When we cannot identify the subject, we forget that the image before us may be a document of some part of the world that we have never seen. Sometimes art and nature meet in such photographs. We call them "abstractions" frequently because they remind us of similar paintings. Actually they are "extractions" or "isolations" from the world of appearances, often literal … Nevertheless, our usual tendency, if we make the attempt to engage, rather than reject, the ambiguous rendering of a subject in a photograph, is to invent a subject for it. What

Interpretations of the landscape, since the beginning of the twentieth century, have been far more adventurous in painting than in photography. I think this is more a reflection of conservatism in the majority of practitioners and viewers than a sign of any intrinsic limitation.

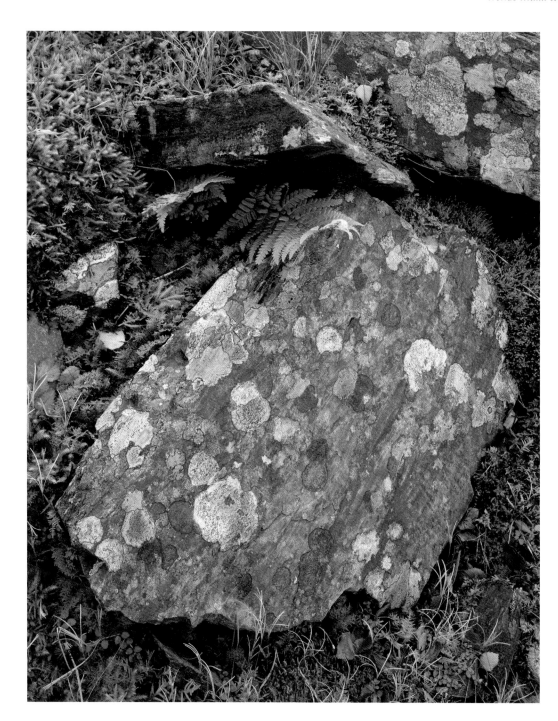

One of the strongest feelings a landscape photographer can convey is a sense of solitude.

There is something about abstraction that is alluring. It forces the viewer to look afresh at the textures, colours and patterns of our world.

we invent is out of the stuff and substance of ourselves. When we invent a subject we turn the photograph into a mirror of some part of ourselves.'

If we make a landscape image that simplifies and abstracts the patterns within our environment, we force the viewer to look at the textures, colours and patterns in the image afresh. It's sometimes only when we can't put a name to something that we can study these details without being influenced by what it is. Recognition can bind us to a single overwhelming interpretation; it forces us to think of it as a particular object rather than a nameless thing, it makes the image definite rather than indefinite, objective rather than subjective.

We can achieve abstraction by confounding those mental routines that we use to understand a two-dimensional image. To do this we need to confuse our interpretation of texture, scale and outline – we need to camouflage our subject. The sole aim of animal camouflage was once thought to be the ability to blend into an environment, but abstract patterns like a zebra's stripes or a cheetah's spots are also there to confuse the outline of the animal. We can apply this principle to landscape images by getting close to our subjects and by photographing only portions of objects, so that instead of a recognizable outline the viewer will see a number of separate, seemingly unconnected, shapes. Another route to abstraction is to exclude clues concerning the scale of the subject represented since (see Chapter 6 for more detail) we use this information to construct a mental model of a three-dimensional space.

It's worthwhile thinking about the mechanisms underlying the forms around us that might give rise to patterns in the natural world. The word 'chaos' normally suggests complete disorganization but surprisingly a branch of mathematics called chaos theory offers an intriguing insight into the hidden structures and patterns of the natural world – from the shape of a fern leaf to a zebra's stripes to the world's weather systems. Mathematics is used by physical scientists to model events in the world using linear equations, where a change in one factor causes a correspondingly direct change to another. Einstein's famous $E=mC^2$ is perhaps the best-known equation of this type. However many natural events do not develop in a predictable and linear way: consider water as it tumbles over a cataract or smoke rising from a lit cigarette resting in an ashtray or air as it becomes turbulent passing over a cliff top. These events are called chaotic and cannot be modelled by linear equations. For a long time physicists and mathematicians had no means of predicting how they would unfurl.

From the early 1960s onwards scientists working in a wide variety of fields, from pure mathematics to meteorology, discovered that quite simple equations reiterated many times could model complex non-linear, or chaotic, systems such as the world's weather. The key to this was the feeding of the answer from one round of computation back into the original equation as the starting point for the next round. A consequence of this reiteration is that tiny changes in value at the beginning of the process produce vastly different outcomes. This is known as sensitive dependence on initial conditions and is often referred to in the phrase 'a butterfly flapping its wings in a South American jungle, it is said, can lead to a hurricane in China'.

Some of these equations, known as fractals, give rise to startlingly beautiful patterns, the Mandelbrot set being perhaps the most famous. These echo themselves at different scales, so that zooming in reveals more and more detail similar to the overall pattern. This is another example of the notion of self-similarity that I mentioned earlier. It is an idea with a long history in Western thought, stretching back to Leibniz in the seventeenth century, and beyond. Leibniz imagined that a drop of water contained a complete teeming universe which held droplets of its own which each contained yet more teeming universes which held innumerable droplets … ad infinitum – a notion, incidentally, that Dr Seuss used for his well-known children's book *Horton Hears a Who*. Self-similarity is also evident in Jonathan Swift's famous poem:

Great fleas have little fleas
Upon their backs to bite 'em,
And little fleas have lesser fleas,
And so on ad infinitum.
And the great fleas themselves, in turn,
Have greater fleas to go on;
While these again have greater still,
And greater still, and so on.

A computer using fractals can be used to model geological and biological forms that exhibit self-similarity, such as a fern leaf where the structure of each leaflet echoes the overall shape of the frond. The photographer Eliot Porter and science writer James Gleick explored this incredible world in their seminal book *Nature's Chaos*. They showed that the variety of patterns in nature that are related to fractals is amazing; the dendritic forms of trees and plants, the geography of a coastline (where the forms of a short section of rocky cove suggest the larger-scale features present along a whole stretch of shoreline), drying patterns in mud, the majestic forms of a mountain chain and so on. The rock patterns in Sandymouth (see page 000) exhibit this self-similarity at different scales within quite a small area, indeed the patterns repeat in a way that does not conform to the conventions expected by our minds and so confounds our interpretation of scale.

The intimate approach doesn't have to result in an abstract image (it can just be a powerful simplification), nor does it always eschew the need to represent the space in an easily understandable way. But, when it needs to be clear, there are alternative methods that can be used to explain the space other than bluntly stating its scale by reference to a known. Intimate views are often taken at a steep angle, the subject displayed almost like a plan, and it might be assumed that the resulting images would lack depth as a result. This does not necessarily follow because the clues that we use to assess depth (using the processes I will describe in Chapter 6) are also present at this smaller scale: converging and diagonal lines (e.g. fault lines in rock), sinuous forms (e.g. branches), overlapping forms (e.g. foliage) and atmospheric effects (e.g. the scattering of light by dust or smoke). These serve to lead the viewer into an imagined space, helping to invoke a sense of place.

Leibniz imagined that a drop of water contained a complete teeming universe which held droplets of its own which each contained yet more teeming universes which held innumerable droplets … ad infinitum.

The photograph allows the viewer to temporarily inhabit the visual field of the camera and, by extension, that of the photographer. Their vision becomes ours and we benefit from their imagination and insight in a very personal and singular fashion.

Sweeping landscapes can still be inspiring and emotive subjects – but focusing on a smaller scale can help us to develop our own vocabulary which we might then apply to the grand view when appropriate.

The choice of particular subject should be personal: if not there is little chance for new insight.

Now let's look again at those questions I raised back in the introduction.

I asked, why is it that one view is considered worthy of representation and another not? The reasons for this can be found in a historical perspective on landscape photography and photography's place within a wider art-history context (more of this in Chapter 6). There are two distinct sets of reasons why we think a particular landscape worthy of a picture, though they often overlap. The first set arise from widely accepted values, which are cultural and historical in nature; they relate to how we, as members of our particular society, feel about landscape in relation to humankind (e.g. threatened by nature, reverent of nature or detached from nature) and the cultural paradigms for representing the landscape which arise from these attitudes (movements like Romanticism or Impressionism and the work of individuals like John Constable, Ansel Adams, Lewis Baltz etc.). What we find interesting in nature is largely determined by our particular society, as is the way in which we are likely to represent it. Whether we are aware of it or not, and whether we like it or not, our photographs are assessed by our peers, subconsciously or consciously, within these frameworks.

The second set of reasons that impel us to make a landscape photograph arise from our personal interests – whether we like mountains or seascapes, cultivated landscapes or wild ones, trees or deserts, black and white or colour, wide views or intimate details and so on. Our approach to photographing the landscape will be affected by the wider cultural reasons I mentioned above but the choice of particular subject should be intensely personal: if not there is little chance for new insight.

We will look in Chapter 6 at how we use vision to comprehend the world around us. This is a very complex area and there's only room in this book to scratch the surface but I'll attempt to show that human vision is as much about mental processing as it is about collecting light. We use mental routines designed to help us make sense of three-dimensional spaces when we decode photographs. Composition is, at heart, simply a way of ensuring that an image is presented in the most clear and forceful way, so an awareness of how these mental routines work is, I would contend, more useful than studying the 'rules of composition' which simply overlie these foundations.

In my introduction I also asked why some photographs, for want of a better term, lack soul. I contend that photographs might lack soul if they denote more than they connote; that is if they more strongly state the obviousness of the representation (tree, lake, cloud, hill etc.) than they evoke what the objects photographed might stand for (time, solitude, depth, escape etc.).

This suggests that the answer to what the secret ingredient is that makes an image transcendent might also be found in a branch of linguistics called semiotics (more on this in Chapter 6) There is no single ingredient that imbues an image with the quality of transcendence;

Photographs lack soul if they denote more than they connote; that is if they more strongly state the obviousness of the representation than they evoke what the objects photographed might stand for.

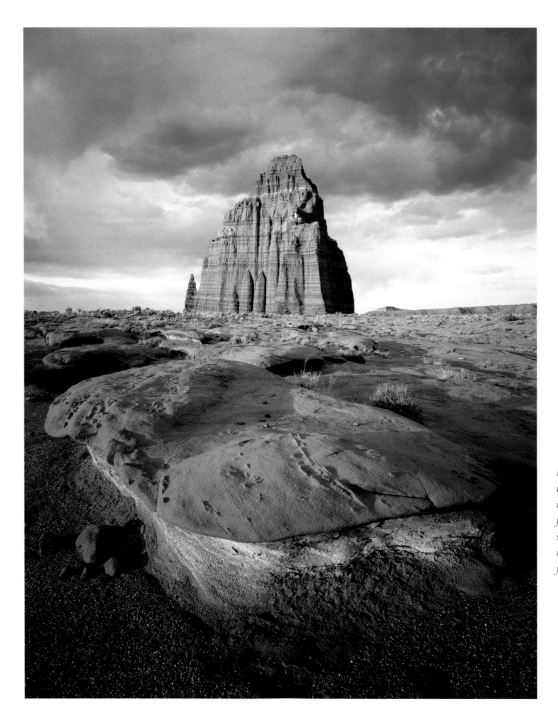

Formal statements are often thought of as style, a word that, from its association with fashion, seems to relate to surface gloss but actually relates to how the image functions.

it arises primarily from the intent of the photographer to move away from the illustrative toward the ambiguous via, as Minor White put it, 'extraction'. These extractions simplify reality and concentrate the viewer's attention on the content with an emphasis on mood and formal elegance. Let's look for a moment at the differences between an average picture postcard, as the archetype of an illustrative landscape, and a transcendent landscape image, something that evokes an emotional response beyond 'That's pretty!'

The first and most obvious point of difference is a lack of mood in the postcard. A picture postcard frequently has a blue sky dotted with cumulus and is shot in midday sun in the summer months. A great landscape is more likely to have a dark sky, low light and towering clouds and to be shot outside the summer months. These are all powerful signifiers of mood – but be careful not to get caught in cliché; remember that other conditions, such as overcast, can be equally evocative. The point is that if you strive for mood you will add a powerful connotative symbol to the image, something that will speak as loudly if not more so than the denotative elements. Avoid making photographs in 'postcard conditions' unless you can make a strong individual statement. The connotations associated with postcards evoke a set of responses which are shallow yet override whatever individual message the photographer is seeking to add.

Human vision is as much about mental processing as it is about collecting light.

The second point of difference is a lack of concern for form in the postcard, a presentation of the view without making powerful formal statements such as foreground interest, strong diagonals, squared up or deliberately skewed rectilinear forms and so on. These formal statements are often thought of as style, a word that, from its association with fashion, seems to relate to surface gloss but actually relates to how the image functions. Strong diagonals, for instance, lead the eye into the image and, if placed knowingly, directly to the principal subject. In a postcard the landscape is often presented flatly, as a set of receding overlapping planes without the use of strong foreground elements to suggest a third dimension. This is never more apparent than in the current fad for panoramic images. Whilst the best of these are beautifully realized, the majority simply rely upon a stretched field of view to make us respond in a 'never mind the quality, feel the width' kind of way. We are not invited to enter the space but only to observe it as a catalogue of objects read, almost as a text, from left to right.

The third is complexity versus simplification. A postcard typically displays all the singular complexity of a particular place: every blade of grass, every tree, every house, every detail whether wanted or not. In contrast, the transcendent image seeks to allude to the general from the particular in the same way that painting traditionally did. The classic approach to this is to simplify, and one of the best ways to simplify is to seek out icons – with the proviso that the photographer isn't repeating the work of others and so falling into the trap of cliché. An icon is a sign that is universally recognized to be representative of a class of objects or as standing for something else – Marilyn Monroe is, for instance, a universally recognized sign in the West representative of all tragic, glamorous female movie stars. An icon often expresses a great depth of connotation – multiple complex and overlapping evocations – and hence is almost like semiological shorthand that, whilst visually simplifying the image, greatly enriches its meaning.

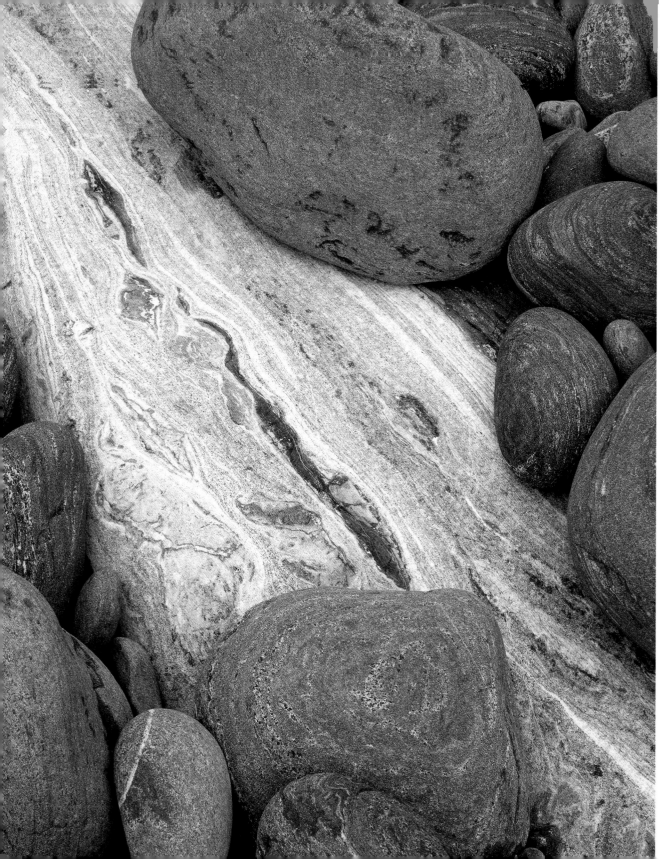

There is no single ingredient that imbues an image with the quality of transcendence; it arises primarily from the intent of the photographer to move away from the illustrative toward the ambiguous via extraction.

A classic example of an icon in the Scottish landscape is the Buchaille Etive Mor, a mountain at the head of Glencoe. Even for people who have never heard of it, its outline and craggy face so strongly evoke the primary characteristics of mountains, what one might call 'mountainness', that it has become an icon connoting all other mountains. The iconic image need not, then, be reduced to a pattern. It can be illustrative, but by simplifying reality we can again constrain denotation in order to emphasize connotation.

The fourth point of difference is openness as opposed to abstraction. In the postcard the landscape is presented 'as is' with no attempt at subtlety or hidden meaning – those qualities after all are not, after all, relevant to its purpose. A degree of ambivalence or obfuscation is necessary for transcendence. A useful metaphor might be to think of the differences between prose and poetry. The former is straightforwardly descriptive, its meaning plain and easily understood, whereas in poetry the meaning is alluded to, elusive and indefinite. Poetry is harder to understand but ultimately more fulfilling. Abstraction might be thought of as one approach to visual poetry. By confounding the viewer's systems of recognition we make the image's meaning elusive but we also make it connote more forcefully than it denotes.

Abstraction, though, can be unsettling for some people. They are only comfortable with a painting or photograph when they can instantly recognize what it represents and they worry that they don't 'understand' an abstract image. They seek the clarification provided by a caption or external critique. They wish instant elucidation rather than a chance for leisurely exploration and eventual revelation. The problem is that they are being far too literal and not visceral enough. Rather than always seeking the definite they should sometimes content themselves with the indefinite. The latter can be a satisfying subject for our inquisitive gaze over an extended period, but the former can so quickly become known and, hence, worthy of only passing attention.

Strive for mood and you will add a powerful connotative symbol to the image, something that will speak as loudly if not more so than the denotative elements.

The perceived need for clarification is abstraction's Achilles' heel and something that famously also applies to the public's appreciation and understanding of conceptual art. This has become reliant upon received criticism. As Jonathan Meades (himself a critic) writes, 'Tom Wolfe took a long time [in *The Painted Word*] to illustrate a truism; that conceptual art is only granted meaning (and comprehensibility) by a text accompanying the work.' For the cognoscenti the image is illuminated by a written work, be it a magazine article, exhibition catalogue description or a transcription of the artist's own words, leaving the rest of us outside in the gloom. When someone doesn't 'get' an artwork it's because they don't understand the language in which it was written, the system of signs into which it fits. It's just the same as trying to read a text in German when you can only read English – you can see the letters but are unable to appreciate their meaning. There's really no way around this except to try to improve and widen the public's understanding of photography.

Both Minor White and the writer and photographer Alan Sekula recognized that meaning in photography lies in a spectrum, or more correctly in a series of spectra, between the two poles characterized as objectivity or subjectivity. White thought that there were five continua and

Sekula six but the definitions of each set largely overlap. For simplicity and brevity's sake I'll just list White's. The meaning in photographs can be classified as inhabiting a space somewhere in the ranges listed below, from:

Record of reality to transformation of reality
Documentary to equivalent
Window on the world to functioning as a metaphor

These are all subtle variations on our old friend the subjective/objective dichotomy. Similarly the viewer's outlook will be within the range:

Literal-minded to sensitive to metaphors

And hence will interpret photographs within this range:

Things for what they are to things for what else they are

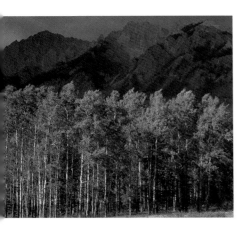

The transcendent image seeks to allude to the general from the particular in the same way that painting traditionally did.

The last two ranges are perhaps the most interesting and potentially the most dispiriting. Interesting because they confirm the possibilities for secondary meanings, confirm that there is no single level of enjoyment to be had from viewing a photograph, but dispiriting because the photographer is not only unable to control these meanings fully but must also be aware that a proportion of the viewers will never know that they even exist.

So, while there are formal differences, ultimately what separates a great photograph from a merely illustrative one is a matter of intent as much as anything else. Images that sing to me will not necessarily even raise a smile with you. There can be no guarantee of transcendence even if striven for, but there is certainly little chance of it arising spontaneously, so the attempt must be made.

I also asked whether what we see and our interpretation of it always relate to labels, to natural language. The short answer is no, an image doesn't have to relate directly to words. When we make an abstract image, what then of the labelling process? If an image is abstracted or ambiguous to some degree then the opportunity for transcendence arises and the feelings and meanings we get from this are not always expressible in words. Abstraction allows the possibility of an emotional response beyond words.

Do we all see the same things when we look out from the cave of our skulls? Yes, and no! We probably all perceive more or less the same shapes, with some discrepancies according to problems like colour blindness or myopia, but we don't all extract the same meaning from those shapes. What processes go on in our minds when we look at an image? We look for meaning, consciously or unconsciously, and meaning arises at two levels: denotation and connotation. The first level is the immediate mental labelling of the elements in the image (from direct links

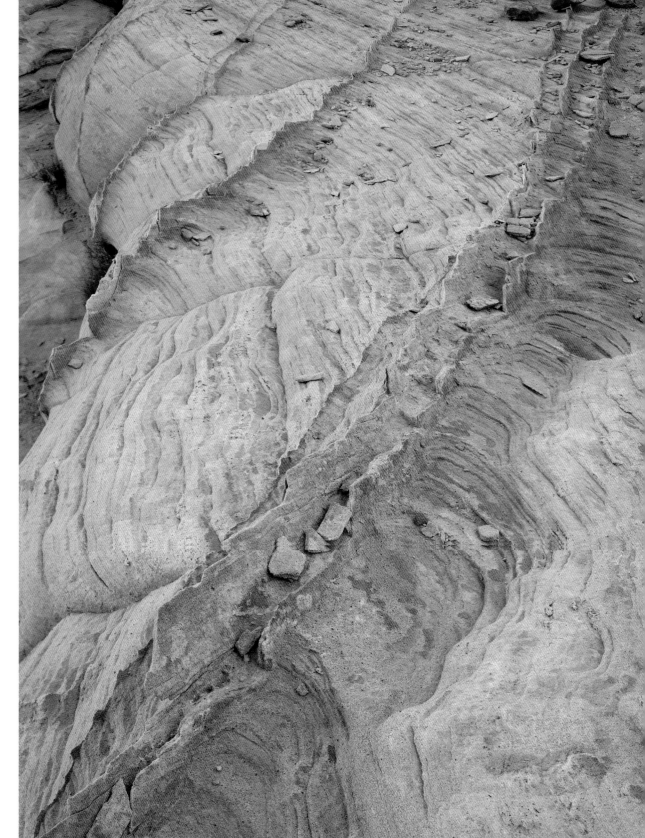

Abstraction might be thought of as one approach to visual poetry.

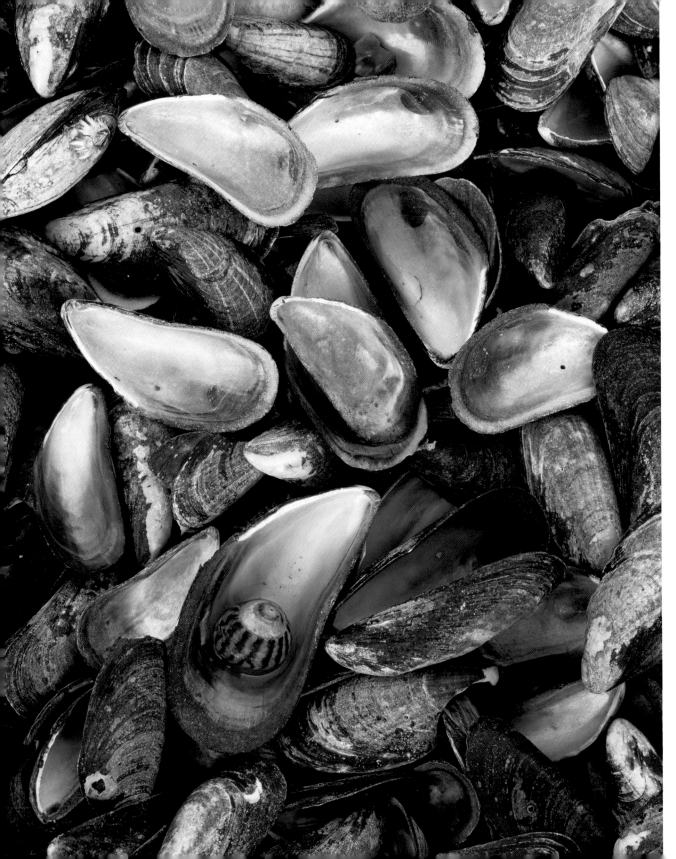

The perceived need for clarification is abstraction's Achilles' heel and something that famously also applies to the public's appreciation and understanding of conceptual art.

between the image and natural language with fixed, though arbitrary, definitions); the second level is what the image evokes in the viewer (meaning carried in other forms of signification which are not universally defined and to some extent personal and subjective).

We now come to what are perhaps the two most intriguing and difficult questions. Where does my mind go to when I'm making a photograph? Simply put, when I am making an image, my mind goes to a place where I can access my creativity. Sometimes I enter an almost meditative state, but this altered state of consciousness is not a mystical condition. It is a state that we are all capable of through application and concentration. By concentration I do not mean the kind of furrowed brow, pained expression that might have the caption 'Thinking!' appended to it but rather a calm exclusion of irrelevances, a state oddly more akin to peaceful daydreaming. It's time to answer the related and crucial question: where does creativity come from?

The capacity for creative thought, and subsequently acting upon it, is inherent in all of us – though often neglected or suppressed. The mystique that surrounds the notion of an artist in Western society is undoubtedly partly to blame. Creativity has traditionally been seen as the domain of gifted, intuitive, often eccentric individuals with turbulent lives – in this vein Vincent Van Gogh is perhaps the archetypal artist. These individuals are mythologized and set apart from ordinary folk. After all, it does the sale price of their work no harm for them to be considered demigods. Whilst it is true that some artists fit this other worldly stereotype the majority do not. Psychologists have long characterized these types of behaviour as originating in the right hemisphere of our brains. The two hemispheres are thought to be responsible for opposite forms of perception and behaviour:

Left Brain	Right Brain
Analytical	Synthesizing
Logical	Random
Rational	Holistic
Sequential	Intuitive
Objective	Subjective
Concerned with detail	Concerned with wholes

It will be obvious from a quick glance down this list that the traits we associate with creativity are all right-brain and that the traits thought necessary for operating a camera are left-brain. It doesn't however help us very much to say where they might originate since we seem to lack a convenient switch to turn on the appropriate behaviours. But there are ways for all of us to harness our creative forces. Psychology has come to the rescue with an analysis of the creative process into four stages: preparation, incubation, illumination and verification. Let's consider them in turn.

Rather than always seeking the definite we should sometimes content ourselves with the indefinite. The latter can be a satisfying subject for our inquisitive gaze over an extended period, but the former can so quickly become known and, hence, worthy of only passing attention.

The preparation stage is when we identify a problem (something to photograph) and collect ideas about how we might solve that problem. These problems require a divergent rather than convergent approach. Convergent thought processes are used to solve problems that have single solutions, like mathematical formulae, where we home in on the solution. In contrast, divergent thought is needed to find a solution to a problem that has many possible solutions – whenever we make a photograph there are a host of alternative ways of photographing the same subject. We need to come up with as many different ways of solving the problem as we possibly can in order to guarantee an original solution. Typically for landscape photographers this stage would be spent in the field, though not necessarily so as we may already have thought of a subject but be struggling with how to tackle it. At the preparation stage we need to be fluent and flexible in our generation of ideas and resist the temptation for closure – keeping our fingers off the shutter release as long as possible. Artists from different media have described this frame of mind as a strange mixture of insight and naiveté – a need always to look at our surroundings, no matter how familiar they may be, as if for the first time. The British photographer Bill Brandt said:

'Most of us look at a thing and believe we have seen it, yet what we see is often only what our prejudices tell us to expect to see, or what our past experience tells us should be seen, or what our desire wants to see. Very rarely are we able to free our minds of thoughts and emotions, and just see for the simple pleasure of seeing. And so long as we fail to do this, so long will the essence of things be hidden from us.'

And Vincent Van Gogh wrote, 'A feeling for things in themselves is much more important than a sense of the pictorial.'

How might we achieve this state of mind? Firstly we need to be receptive and open to possibilities, but this alone is not enough. We need to shut out the everyday babble of thoughts unrelated to the task at hand; we need, in short, to concentrate – almost to meditate. When I'm lost in picture-making I'm often unaware of physical discomforts, my mind is focused only on making the image; irrelevances like wet clothing or cuts or utility bills or when I'm next going to eat are banished from my mind. Minor White wrote, 'If you could stop the shouting of your own thoughts in your ears, you might be able to hear the small voice of … a pine cone in the sun.' He compared the preferable state of mind to that of an unexposed piece of film, static and seemingly inert yet pregnant with possibilities, 'so sensitive that a fraction of a second's exposure conceives a life in it'. Any image might feasibly be formed upon the film and we should be equally ready to accept what passes in front of our eyes, not blinkered by convention or expectation. We mustn't deny ourselves opportunities by blindly following a plan to make a predetermined image, and we must remember that whilst experience teaches us what *does not* work it doesn't teach us *what will* work until we've tried it. Minor White felt that this receptive blankness was at the heart of image-finding: 'We should note that the lack of a pre-formed pattern or preconceived idea of how anything ought to look is essential to this blank condition.' We must be willing to experiment and take risks in order to make great images; above all we must be willing to accept our own intuition. This requires us to have confidence in our own

Some people are only comfortable with a painting or photograph when they can instantly recognize what it represents, they worry that they don't 'understand' an abstract image.

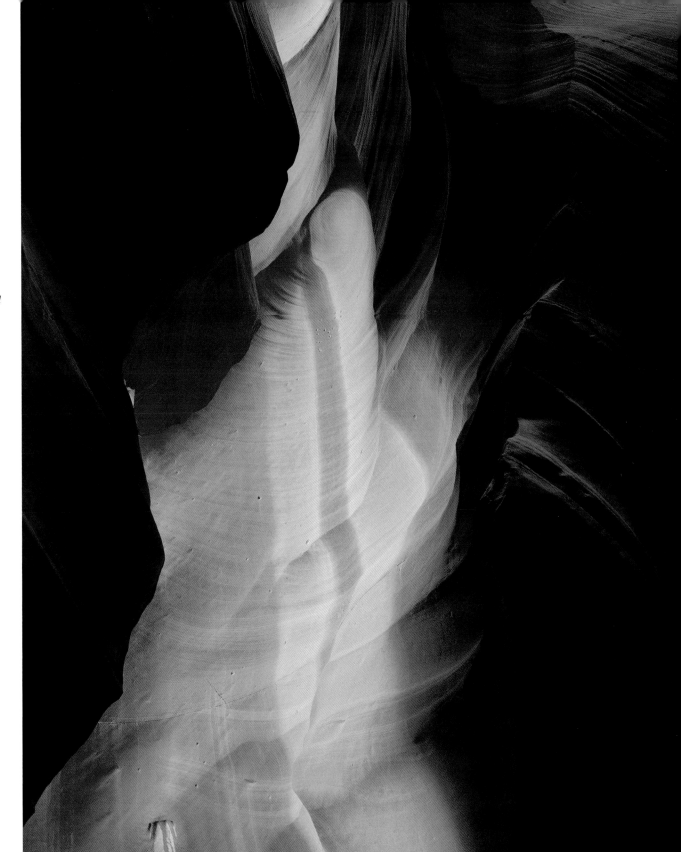

*If an image is
abstracted or
ambiguous …
the feelings and
meanings we
get from this
are not always
expressible
in words.*

abilities, something we gain through practice and experimentation. Every time we press the shutter we need to make a leap of faith as well as a leap of the imagination.

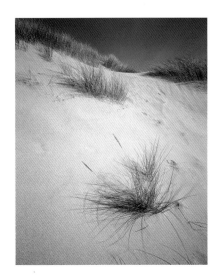

The next stage is incubation. When problems arise in our everyday lives we often follow the age-old advice of 'putting it on the back burner' for a while or 'sleeping on it' until the solution occurs to us. This is a way of letting our subconscious work at a synthesis of the different elements of the problem and so arrive at a conclusion. We've probably all had the experience of going out to make images but being unable to find any satisfactory compositions, yet we might return to the same location in similar light and see pictures all around us. In the intervening time we will have incubated ideas about how to approach the subject from our original visit. This is why we often find it difficult to make images in a new environment; we have to spend time assimilating many different complex factors and ideas before we are ready to progress to making images. If you are stuck for a solution, leave the problem to stew rather than worrying at it like a terrier with a bone. When you return to it, ideas will flow more freely.

The third stage is illumination. This is the sudden realization of a solution to the problem, in our case how to make the photograph. History is littered with anecdotes about such moments from other arenas of creative thought, from Archimedes jumping out of his bath and crying 'Eureka!' to the moment when Isaac Newton watched an apple fall and understood the notion of gravity, to Darwin extrapolating the theory of evolution from his study of finches in the Galapagos Islands. It is this seemingly unexpected insight which bolsters the myth of a kind of divine genius granted to only a few individuals. But this is just part of a process; neither Archimedes nor Newton nor Darwin arrived at their particular moment of insight out of the blue. They all worked on the problems for a considerable length of time, from months to decades. In fact, in the case of the last two revelations there is strong evidence to suggest that these particular moments are retrospectively applied myths describing events which never actually happened. We all have little eureka moments every day; we use this process when doing mundane tasks like trying to remember somebody's name or solving a crossword. 'Aha!' we say to ourselves, often not realizing that we have emulated such august individuals in deed, if not in scale. It is critical that we delay closure in the first stage if we are to reach a new or deep insight. The smaller formats in photography sometimes seem to encourage premature closure. It is easy with 35mm to 'snap away' rather than stand back and analyze how to tackle a particular subject, though this matters little if the photographer persists with a subject rather than making an image or two and then walking away. Persistence can equate to the preparation and incubation stages; like a painter's working sketches it becomes part of the problem-solving process. Working on large format, as Adams and Weston did, forces the photographer to slow down. The physical processes for setting up the camera are a little cumbersome and the ensuing ritual allows time to analyze the problem and to look at many different solutions, and provides an opportunity for incubation before illumination. Indeed the slowness and cost of large-format film positively discourage premature closure.

The final stage is verification – reality-testing our solution by implementing it and making an image. Obviously the solutions won't all be masterpieces but the longer we can delay closure the

Sometimes when making a photograph I enter an almost meditative state. It is a state that we are all capable of through application and concentration.

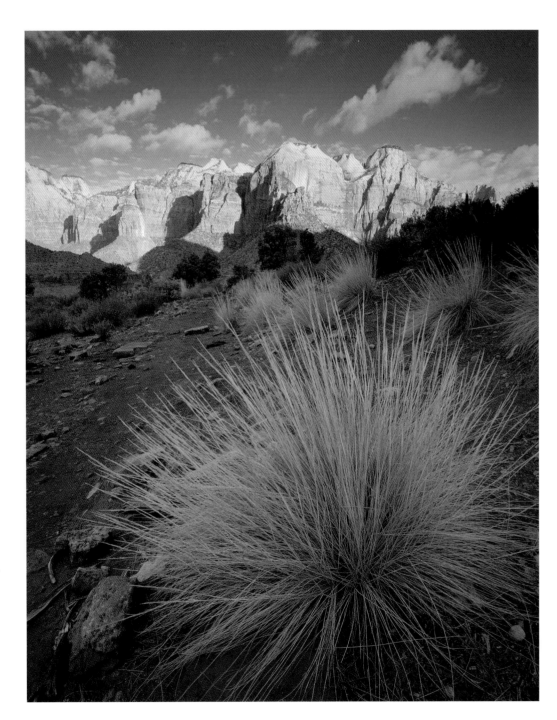

Images which sing to me will not necessarily even raise a smile with you. There can be no guarantee of transcendence even if striven for, but there is certainly little chance of it arising spontaneously so the attempt must be made.

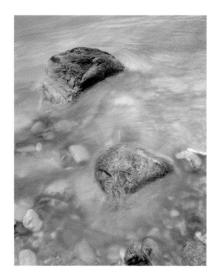

'Most of us look at a thing and believe we have seen it, yet what we see is often only what our prejudices tell us to expect to see …'

Bill Brandt

better the chance. If a particular photograph, a verification, fails to meet our criteria then we must simply start again from square one. One great advantage of digital photography is that the verification is instantly available for the photographer to assess without the traditionalists' agonized waiting for hours or days.

The hardest part of the process is the delaying of closure because evolution has programmed us to quickly seek the simplest solution to perceptual problems. You'll see in Chapter 6 that the overriding assumption we make when we look around us is that our environment is not inherently deceptive. To get past this programming we have to trick ourselves into seeing things in, literally, a 'new light'. One way of doing this is simply to study your subject for a long time until it no longer seems familiar, so that new relationships and patterns arise in the subject (try staring at any word for long enough and you will see that it suddenly becomes disconnected from its meaning, the ordering of the letters strange and unfamiliar). The photographer Duane Michals declared, 'I do not believe in the visible. I do not believe in the ultimate reality of automobiles or elevators or the other transient phenomena that constitute the things of our lives … Most photographers believe and accept what their eyes tell them, and the eyes know nothing. The problem is to stop believing what we all believe.' Our perception is programmed to look for patterns and to switch off when a plausible solution has been found. For photographers to see something afresh and for this to excite the viewer, the trick is to go beyond the obvious and to embrace the ambiguous. Look hard, think long and only then press the shutter release.

The obvious conclusion to be reached from analyzing the creative process is that there is no single correct approach to making an outstanding photograph. In fact, by definition an outstanding image will have arrived at a unique and personal solution to the divergent problem that the subject had posed the photographer. For this reason Edward Weston wrote, 'to consult the rules of composition before making a picture is a little like consulting the law of gravitation before going for a walk. Such rules and laws are deduced from the accomplished fact; they are the products of reflection'.

What then of the essence or essences of photography that I've been searching for? Photography's essence has often been seen simply as its supposed complete objectivity, something that is in some ways a by-product of its congruity with human vision. There have been powerful reasons of self-interest at work to support this simplification. The term 'objective' has been used as a tool by the champions of other media to traduce photography in its entirety as mechanistic. But it has also been used by practitioners within the medium to denigrate photographs that they dislike as mere illustrations, and by comparison to advocate their own more 'subjective' approaches as evocative. Photography is, however, irreducible to such a simplistic dichotomy. No matter how objective a photograph might seem it is the product of a great many subjective decisions. Subjectivity is a two-edged sword, cleaving reality when the image is made and again when it is viewed to reveal a subtly different slice. We should rejoice in the dual nature of subjectivity because it allows the photographer expression and the viewer the possibility of interpretation beyond what is denoted. That subjectivity is unavoidably present in

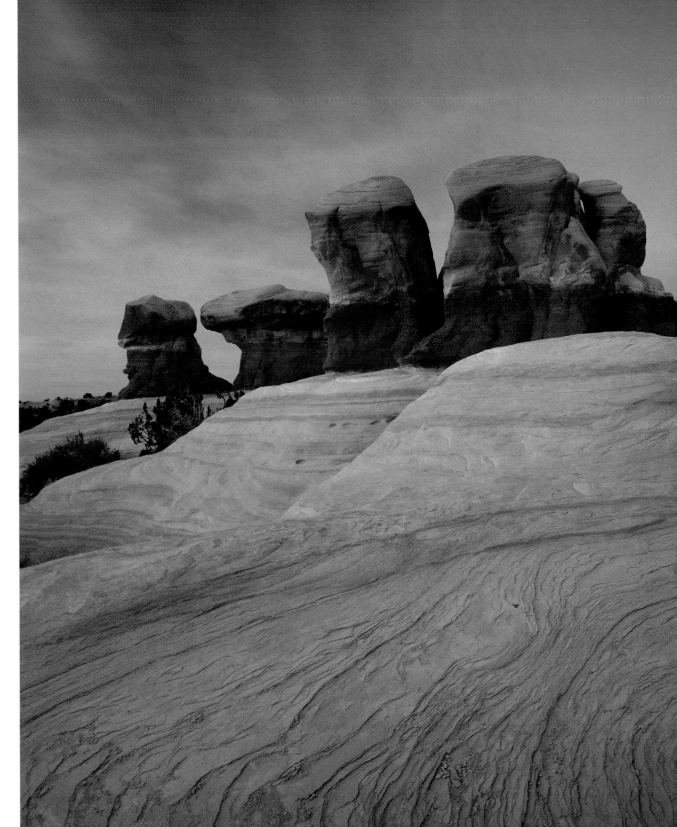

When making an image we need to shut out the everyday babble of thoughts unrelated to the task at hand. Minor White compared the preferable state of mind to that of an unexposed piece of film, static and seemingly inert yet pregnant with possibilities.

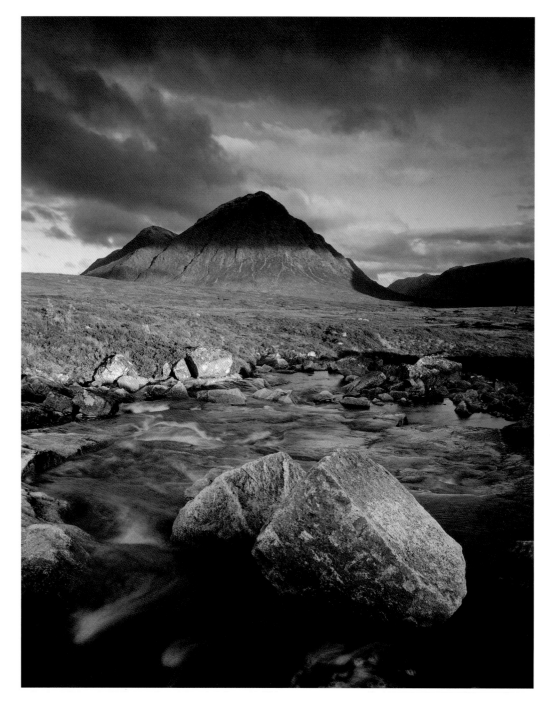

Analyzing the creative process shows that there is no single correct approach to making an outstanding photograph. In fact, by definition an outstanding image will have arrived at a unique and personal solution to the divergent problem that the subject had posed the photographer.

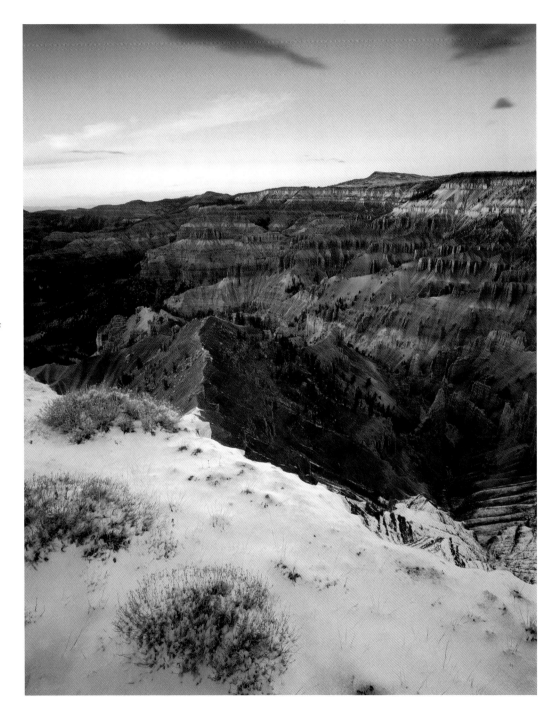

We should rejoice in the dual nature of subjectivity because it allows the photographer expression and the viewer the possibility of interpretation beyond what is denoted.

I can't get excited about a narrow focusing on the process; this should be subordinate to the product. The camera is a tool; by all means love it for its capabilities but don't worship it.

5

My
Practice

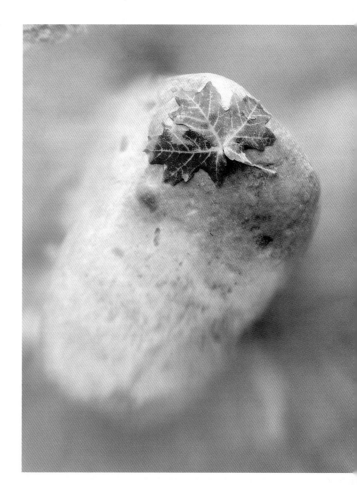

The application of theory

Craft is important but it's not paramount; vision is.

It might seem an odd thing to write at the start of a technical section but I have to admit that I've never understood the strong demand for comprehensive technical details from magazines and fellow photographers. For me, the joy of photography is as an avenue to self-expression and, crucially, an attempt to communicate my vision to others. I can't get excited about a narrow focusing on the process; this should be subordinate to the product. Imagine a cook who went into raptures about wooden spoons (the length of the handle, the type of wood, the weight – luckily for me I can't think of any more characteristics!) but who could not produce an edible meal. By any sensible definition they would not be called a cook! The camera, like the wooden spoon, is a tool; by all means love it for its capabilities but don't worship it. The famous American photographer Edward Weston wrote, 'Given a big enough artist … he will make of himself a consummate craftsman to better express his thoughts.' You don't need an encyclopaedic knowledge of the technical details of photography, you only need to know enough to be able to make an image to your satisfaction, and no more. Craft is important but it's not paramount; vision is.

That the demand is there for technical details, and that their inclusion is not merely an exercise in padding by magazine editors, has been proven time and again by the plaintive cries from the readership for their return whenever a magazine has dropped technical notes. But we have to ask ourselves, what use are they? Will the light be the same when another photographer visits the same location? No! So, why do we need the specifics of exposure, why do we need the f-number and shutter speed? Will the photographer be using the same lens or even the same format? These are very relevant questions since the effect of aperture size changes with focal length and the size of image produced in camera; f22 on a 28mm lens on 35mm will almost certainly produce an image that is acceptably sharp from front to back whereas the same aperture used on a 270mm lens on 5x4" will categorically not do so. Technical details are only really helpful if extremes have been used to obtain an effect, for example, very long exposures or very wide apertures. Because of the large number of variables involved, a vague term like slow shutter speed or small aperture is almost as helpful as an exact number. What's of much more relevance is the approach taken by the photographer to his subject and it is this question of intention in relation to technical details that I will concentrate on in this section.

Authors often discuss various 'rules' of composition (rule of thirds, use of a foreground object to give depth, aerial perspective, diagonals, 'S' shapes, a lone object, pattern and repetition, don't break the horizon/break the horizon) without saying how or why they might work. Underpinning all these 'rules' are the mental perceptual routines that I'll discuss earlier in the book. Diagonals, for instance, fool the eye into perceiving depth in the same way as converging parallel lines do. Our minds look for edges as a survival trait, to stop us falling off things or bumping into them. When we see an edge at an angle to the frame we think of it as receding as an effect of scale. When the edge or line returns across the frame our eyes follow it 'deeper' into the image, and this to some extent explains why meandering lines or 'Z' shapes are so appealing; our mental imaging routines are imbuing a sense of depth in a two-dimensional image. 'Good composition' is at heart about making the best use of the clues in the scene used

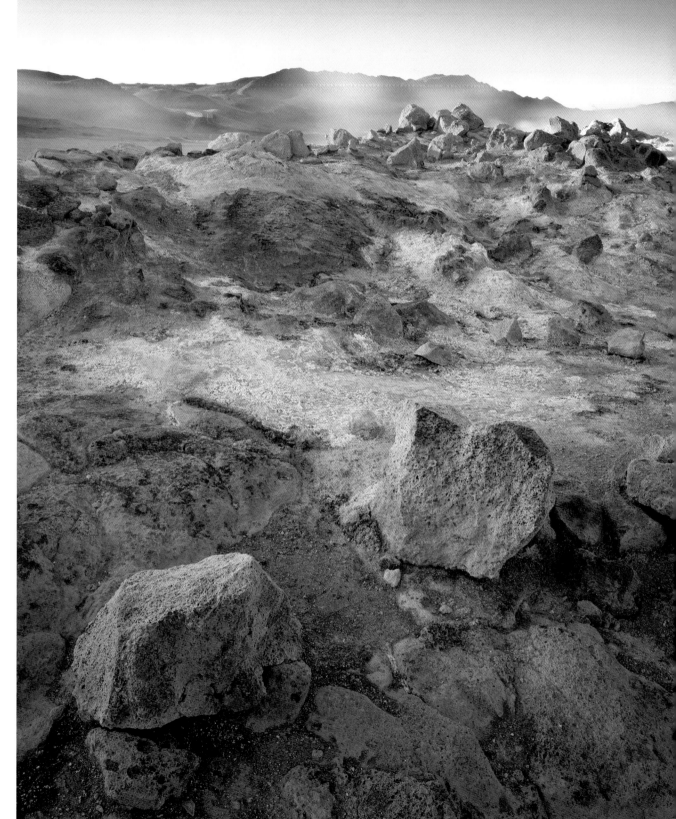

Good composition is at heart about making the best use of the clues in the scene used by the perceptual routines. Clarity is the key and clarity springs from simplicity.

by the perceptual routines. Clarity is the key and clarity springs from simplicity. Images produced by blindly following the 'rules' without personal insight will be empty vessels.

The only technical details that might be universally educative to other photographers are focal length and filtration. The former can be used to assess the transformation of perspective from 'reality' to photograph. The latter can help the viewer to understand a number of different factors, including the colour of the light and the contrast ratio of the image if graduated neutral-density filters were used.

Of all the transformations inherent in photography, the hardest for the photographer to master is contrast. Because our eyes have a constantly varying aperture we often don't notice how much brighter the sky is than the foreground, or even that light levels are rising or falling whilst we are setting up. These constant variations are not a problem if you are using a through-the-lens metering system or automatic exposure but if you are using a hand-held meter, to ensure accuracy and fine control, you must always make the final meter reading immediately before making an exposure. It is the ratio between the brightest and darkest tones that we wish to render on film that causes the most difficulty, especially on colour transparency film. Only four to four and a half f-stops are renderable on transparency. Beyond that range the film becomes clear at one end and black at the other. Large areas of either are undesirable in the sense that they lack information, though I always feel that black is preferable since it more effectively evokes a mood. The photographer using colour transparency was once forced to make a stark choice about what information to lose or whether to recompose to minimize the loss. This presented a severe artistic limitation to people like Ansel Adams, who were used to being able to render tones across ten stops on black and white film, and probably accounts, more than its limited availability, for his lack of enthusiasm for colour.

In recent years high-quality graduated neutral-density filters have become widely available from manufacturers like Lee Filters. These provide the photographer with a tool to control contrast by selectively darkening areas of the image. But choices must still be made, the most critical one being where to place the zone of transition so that the filtered portion is not noticeable. For instance, when photographing a subject and its reflection in still water the photographer must be aware that if he seeks to balance the brightness of both the image will look unnatural: this is because we expect the reflection to be darker than the subject reflected.

I still feel that for the majority of landscape images filtration or manipulation should be invisible – that the image should aspire to congruity with human vision. This is not because I feel that it is morally wrong to manipulate reality, as I discussed earlier, but rather that, to the trained eye at least, it becomes a distraction. A heavy or obvious use of filtration is in itself a sign, and in most cases a sign that will drown out the subtler message within the frame. Sadly it speaks to other photographers of a degree of ineptitude, most of us whom, after all, habitually examine photographs minutely for the slightest flaw.

A heavy or obvious use of filtration is in itself a sign, and in most cases a sign that will drown out the subtler message within the frame.

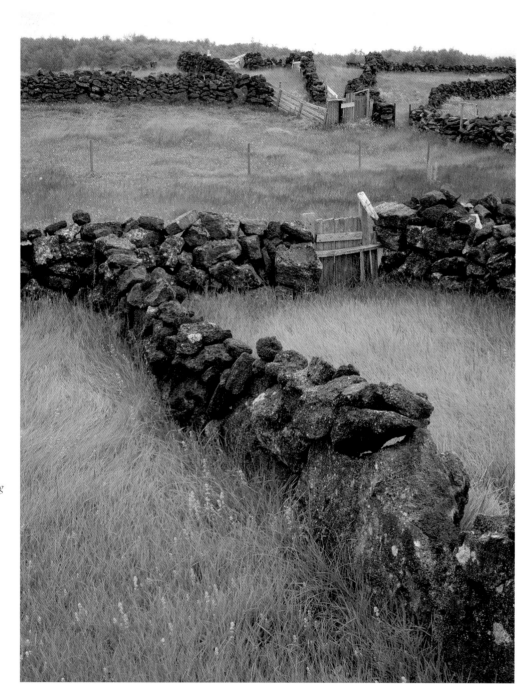

Images produced by blindly following the 'rules' without personal insight will be empty vessels.

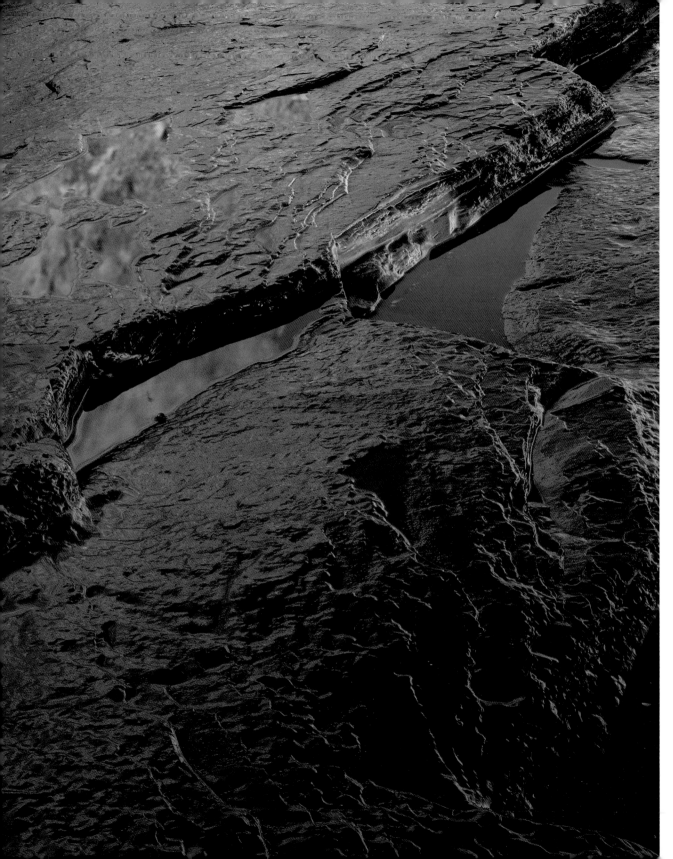

Control over
the level of
detail is very
important in
photography:
too much detail
becomes
confusing and
tiring whereas
too little can be
confusing and
boring.

You may have noticed that a great many of the 'masters' use large-format cameras. This is not just because of the increase in quality so afforded but also because there is a distinct advantage to viewing the image upside down. You will remember that as part of the preparation stage of the creative process I counselled that a photographer should see their subject in a new light. The transposition of the image upon the ground glass of a view camera effects this fresh perspective because our recognition systems become partially uncoupled from our vision and we can concentrate more on the arrangement of forms within the frame. Bluntly put, if it works upside down it will be great the right way up. Because of the cost and difficulties involved in using a view camera one tends to make fewer images. But I have certainly noticed that the percentage of images that I consider successful is far higher since I started using a view camera exclusively. It might not suit everyone's pocket or temperament but even in the digital age there is still a place for the oldest type of camera.

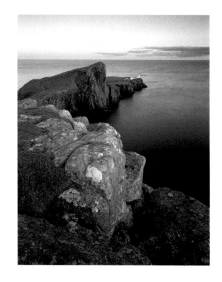

The photographs in this book are all in colour, yet most of the masters of photography I've referred to worked in black and white. It is much harder to make a great photograph in colour than in b/w because the complexity that the photographer must control has increased many fold, since not only form and tone but also colours must now be balanced. However, the level of abstraction is reduced, the image appears to be closer to 'reality'. This perhaps explains why, with a few notable exceptions, colour photography has not been the choice of the great photographers like Minor White, even though colour films have been widely available for over half a century. It is not simply the difficulty of the task but also that it is harder to accept colour photography as a transformation. Its denotation seems overwhelming; it's just too real. Colour tends to makes us concentrate on the surface whereas monochrome leads us to examine edges and structure. Colour itself isn't the problem, the critics don't appear to have the same difficulty with painting – we don't hear them saying how much better an artist Monet would have been if only he'd worked in black and white! It's the combination of colour with faultless mimesis that causes the predicament, and the solution is, once again, extraction. Black and white was felt too close to reality for comfort during the first fifty years of photography and colour photography now occupies the same position. At the moment art photographers working in colour tend to use a subdued palette, a nod towards modern art's intellectual distance perhaps, but for most photographers this conscious avoidance of living colour seems a sign of timidity akin to the Pictorialists' mimicry of painterly manipulation. There is surely no reason for photography still to remain in awe of its older sibling; in fact if novelty is the name of the game in art the one thing that hasn't been tried until the last decade is seriously minded vibrant colour photography.

One of the complexities of colour photography is that the result might not conform with our own vision because of a colour cast. The problem is that we may not be aware of a shift in the colour of light at the time we make the image. As I pointed out earlier our vision is normally colour corrected, an effect known as colour constancy. As a result we need to teach ourselves to notice subtle shifts in colour, not only in order to be able to correct it but also to know when to leave well alone. In cloudy conditions we frequently employ the 81 series filters to achieve a neutral result more consistent with how we perceive such situations. When using long

I still feel that for the majority of landscape images filtration or manipulation should be invisible – that the image should aspire to congruity with human vision.

exposures (over 15 seconds) on Velvia film we might need to reach for an 85C filter instead. This is because Velvia colour shifts toward green with reciprocity failure. The magenta component of the 85 series can be used to counter this. But not filtering is sometimes as important a decision as using a filter. On an overcast day or in deep shade we might want to emphasize the coolness of the light to evoke a cool mood. Consciously not filtering can also be used to produce a colour

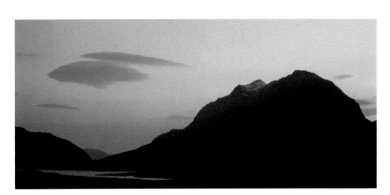

contrast, as in 'Valley of Fire' where the blue of the sky is reflected in the shadowed side of each fin. I might have been tempted to use an 81 series filter to make the image 'neutral' but this would have drowned this subtle effect.

Evolution was the driving force behind our ability to recognize colours in different lighting conditions – it's useful to be able to recognize food or a hazard whatever the colour of the illumination. But photography hasn't been around long enough for us to evolve any specific adaptive traits, nor is it likely to be. Consequently we are spectacularly bad at some visual tasks that would be really very useful for photographers. We find it very difficult, for instance, to judge the relative brightness of colours. We tend to think of certain colours, such as brown, as 'dark' even though in any given scene they may be brighter than a 'light' colour.

If novelty is the name of the game in art the one thing that hasn't been tried until the last decade is seriously minded vibrant colour photography.

So, let's look at the problem of assessing tones in a scene. Do we want that snowball in the shadow to be white or that piece of coal in the sun to be black, and how might we achieve that? A lightmeter assumes that everything is 18% grey (a mathematically modelled mid-tone) because it cannot know otherwise — leaving us with the problem of where to place the tones. If you are using through the lens metering you might be happy to let it 'average' the whole scene, and most of the time this will produce an acceptable result. But if you want to be precise with your metering (especially if you want to use graduated filters to control contrast precisely) then a hand-held spotmeter provides the best solution. But since our eyes aren't very good at judging a mid-tone in colour, unless you spotmeter all over the scene finding a mid-tone is largely a question of experience. In temperate climes sunlit grass is generally a good mid-tone. But if we have a subject which is very high contrast (e.g. a waterfall with wet black rock around it) or very high key (e.g. a snow scene) or very low key (e.g. conifers) then we may not have a mid-tone in the scene at all. Exposing using a straight reading off any of these will not produce an acceptable result because it won't look as it did to our eyes. In order to get the best out of these conditions you need to know the range of stops that your film is capable of rendering and work back using that information. As I noted earlier, a film like Velvia has a range of four to four and a half stops between black and white. In my experience the mid-tone doesn't actually fall halfway between these points but slightly nearer the white end, something like this:

f8	f11	f16	f22	f32
Black		Mid-tone		White

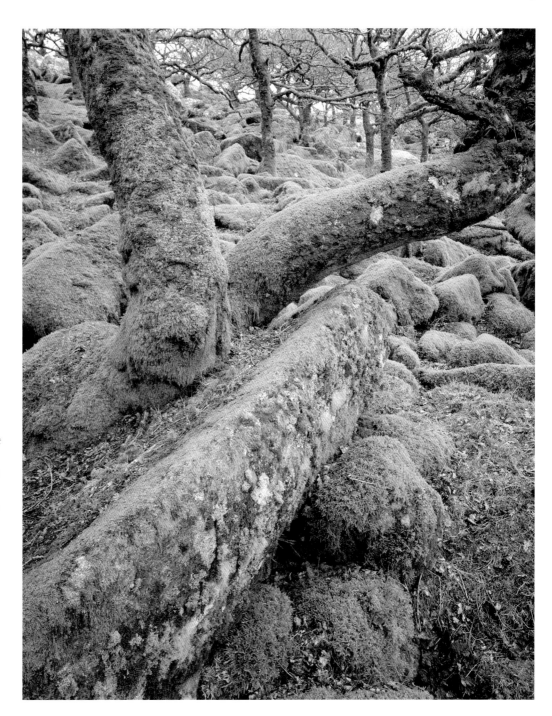

Woodland is probably the most difficult subject to photograph because any image has to tame what I call the three C's: complexity, chaos and contrast.

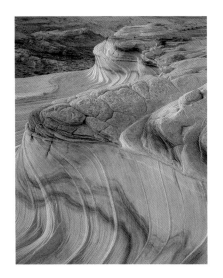

The intimate landscape is not just defined by scale but also by its granting of an apparently exclusive access to the viewer.

So, in our high key example we might take a reading off the snow and, wishing to retain detail but still have it rendered as white, make our exposure a stop and two thirds down from this reading. Similarly with a dark subject the photographer can assess what he is willing to be rendered as black and make his exposure two and a half stops higher than this reading. In both cases it will be necessary to check the overall contrast range of the scene to see what tones might not be renderable and if possible to use a graduated filter to darken them down and bring them into the acceptable range.

Sunlit woodland is probably the prime example of a subject where contrast is a particular difficulty. Woodland is in any case probably the most difficult subject to photograph because any image has to tame what I call the three C's (complexity, chaos and contrast) for it to translate into two dimensions successfully. None of them is insurmountable on their own but in combination the task becomes almost impossible. Graduated neutral-density filters are often not an appropriate solution to contrast in a wood because the darkened portion of the frame will be obvious amongst the branches and trunks of the trees. The only solution is to be very careful about framing and exposure in order to minimize large areas of deep shadow or burnt-out highlights.

Actually standing in a wood, one can easily comprehend the space because the physical feedback from our eyes assigns relative positions for each trunk, branch and leaf. Whilst not diminishing the complexity, this information literally lets us know where we stand. In a photograph, stripped of the physical feedback, the complexity of the scene can overburden us with superfluous information. Control over the level of detail is very important in photography. We need a certain level of detail as this provides the clues used by the mental routines I outlined earlier. But too much detail (as in a wood) becomes confusing and tiring whereas too little (as in a block of solid colour) can be confusing and boring. So again try to choose a framing that simplifies the subject as much as possible.

One of the most commonly quoted directives to photographers is to include a human figure, or other object of known size, in a landscape in order 'to give it scale'. This is dubious advice, even when applied to a vista. There are at least two other reasons why I feel that human figures should generally be excluded from landscape images.

Firstly, in any image including a human our attention will automatically be centred on the figure. There is a Gary Larson cartoon in which a man and his dog are fleeing a nuclear attack by car. You can see mushroom clouds rising all around and the man's face is a mask of panic. But the dog, despite the coming Armageddon, is only concerned with looking at another dog which he has spotted urinating against a fire hydrant. We humans are equally obsessed with our own kind; it has been estimated that over 90% of all photographs include humans, which is hardly surprising given that we are highly social animals. If a person is included in a photograph we cannot help but concentrate on them; we look at their face, their sex, their clothes, their stance, we assess their ethnicity, their wealth and their social status. The figure (unless it is naked!) will

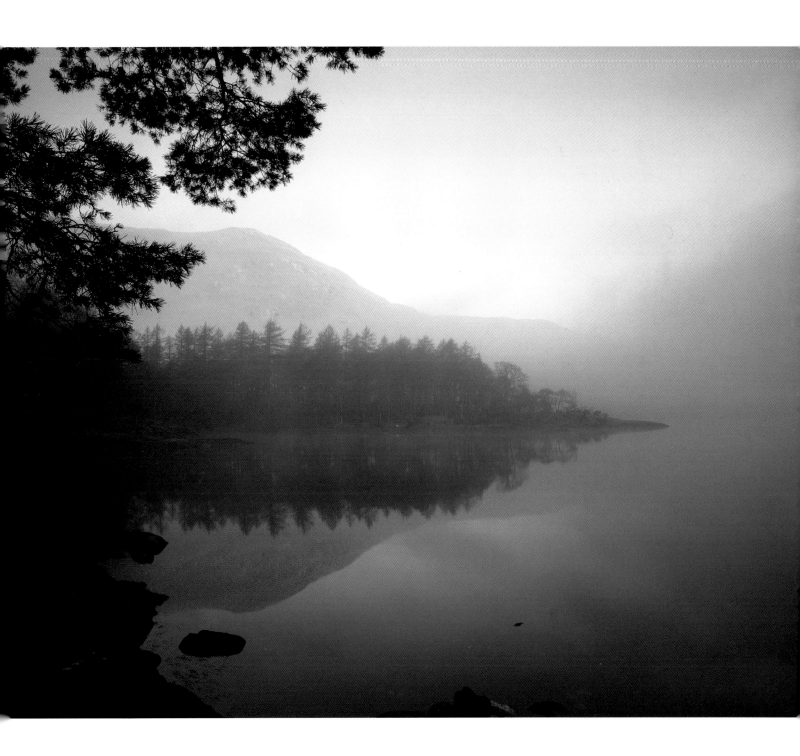

also serve to anchor the image to a certain era. A landscape photograph including a figure is more about that time and that individual in relation to the landscape than it is about the landscape itself or any connotation arising from it that the photographer is trying to convey. The photograph becomes a literal, social and historical document rather than a work of art taking a portion of our environment as its inspiration.

Secondly, another human figure in the frame necessarily denies the possibility of intimacy. The viewer is no longer a single, privileged, spectator but merely another member of the throng. For deep contemplation, in a landscape photograph as much as in life, we need to be able to shut out the clamouring crowd. A human figure becomes an unavoidable distraction and irritation from the silence we seek in the image, like a buzzing fly that can't be driven away. The intimate landscape is not just defined by scale but also by its granting of an apparently exclusive access to the viewer.

For these reasons I would counsel caution when including a figure in a landscape. Those who advise a figure's inclusion are, I feel, essentially uncomfortable with the natural world. Their viewpoint is fundamentally anthropocentric; they seek the reassurance of human scale and company. In an age when the majority of the population in the West live in an urban or suburban environment it's hardly surprising that people find the natural world intimidating. How many of us could survive more than a week or two without access to a supermarket, tap water or central heating? Only a tiny percentage could. We are in love with the idea of the wild, but in most cases allergic to the reality of it. We know in our hearts that living off the land, as opposed to from a supermarket, is muddier, bloodier and more exhausting than the last-minute shop on Christmas Eve.

If we want to make our work more than merely illustrative we must allow second-order meanings to dominate. However, it might seem that, since secondary meanings are potentially so numerous and personal, there is a danger that the photographer will completely lose control over how their image is interpreted. The photographer can, however, limit the degree of drift of meanings in several ways.

Firstly, and most obviously, by working within a recognized genre. Genres tend to limit an audience's expectation from an image; they are loosely associated systems of signs with generally accepted, though indefinite, limits. For instance, we all think we know what we mean by the genre of landscape but, as I've indicated, it has had widely different meanings to people in different cultures and times. A photographer might choose to work within a particular genre – such as Romantic landscape – but classification is also often imposed from outside by their peers or critics so this is not a foolproof way of steering interpretation.

Secondly, by captioning the work. Single images are impossible to decode consistently for all viewers – but the attachment of a caption guides interpretation if not actually fixing meaning. A caption steers the interpretation of the image because text, whilst it may not be a universal

The transposition of the image upon the ground glass of a view camera effects a fresh perspective because our recognition systems become partially uncoupled from our vision and we can concentrate more on the arrangement of forms within the frame.

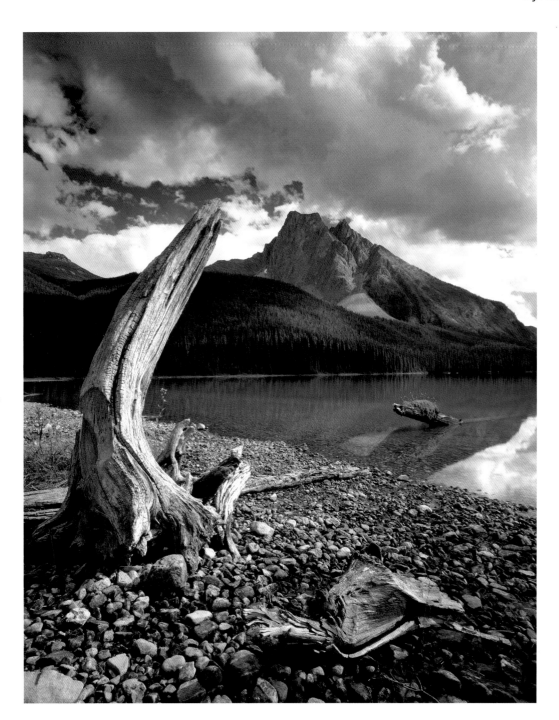

It is much harder to make a great photograph in colour than in b/w because the image appears to be closer to 'reality'. It is perhaps harder to accept colour photography as a transformation. Its denotation seems overwhelming; it's just too real.

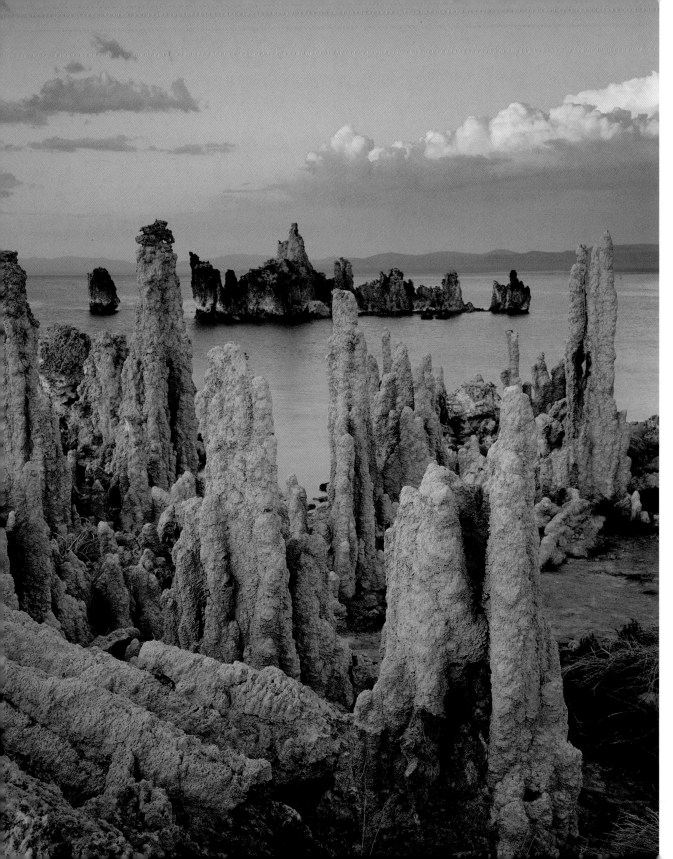

Single images
are impossible
to decode
consistently for
all viewers –
but the
attachment of
a caption
guides
interpretation
if not actually
fixing meaning.
A caption
steers the
interpretation
of the image
because text,
whilst it may
not be a
universal
system of signs,
is certainly the
dominant
system.

system of signs, is certainly the dominant system. A caption tends to keep the meaning of a photograph within certain bounds. People often seek the comfort of words, they want to be guided in their interpretation rather than have to strive for an understanding on their own, and so a caption is often the first thing they look for when approaching an image. Captions are usually factual for producers of windows ('President George Bush visiting Iraq yesterday') but more likely to be lyrical ('Evening's Edge') or determinedly unhelpful ('Landscape No. 3') for photographers making mirrors. In any event they add another layer of signification that, whilst guiding interpretation, interacts with the signs within the photograph, sometimes producing a very different set of connotations than those arising directly from the image. Text can also, of course, appear within the image itself and will then also inform or change our interpretation of the picture. Look at the image on page 121 and try to imagine it without the 'Too pooped to pump' text to see what I mean.

Thirdly and finally, by simplifying reality. As I noted in the last chapter, the smaller the range of signs that a photographer includes within an image the more tightly they can control the meanings arising from it.

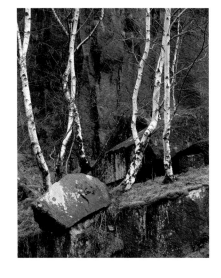

Perhaps of greater significance than the problem of imbuing an image with meanings is the problem of making someone spend the time to look at it. Sadly, photography's ubiquity in combination with its apparent interchangeability with human vision means that we sometimes have to force ourselves to look. You could argue that it is the photographer's responsibility to make us look, to shock us or seduce us into spending some of our precious time studying their images – and I would have some sympathy with that view if it were not for an endemic inattentiveness regarding photography. Photographs are frequently dismissed before they have even been glanced at – which is disrespectful, to put it mildly, considering the effort that serious photographers put in to their image-making. So I feel that an effort should be made through education to make people value photography as highly as other forms of representation. This is already the position in many countries, notably the USA, but sadly in the birthplace of Fox Talbot photography is still largely thought of as a second-rate medium.

We all have the potential for individual expression but to realize this as a visual art we need to develop not only our vision but also the means to communicate it. I hope that I have pointed the way to some tools for improving your communication skills through photography.

People often seek the comfort of words; they want to be guided in their interpretation rather than have to strive for an understanding on their own.

We all have the potential for individual expression but to realize this as a visual art we need to develop not only our vision but also the means to communicate it.

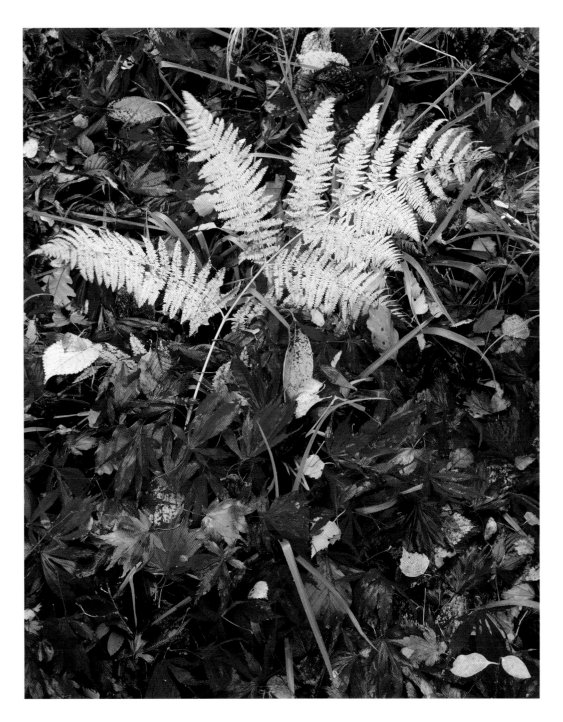

Meaning in a photograph derives from a whole range of signs and symbols that we understand in a context external to the image.

6

Beginnings and In Plato's Cave

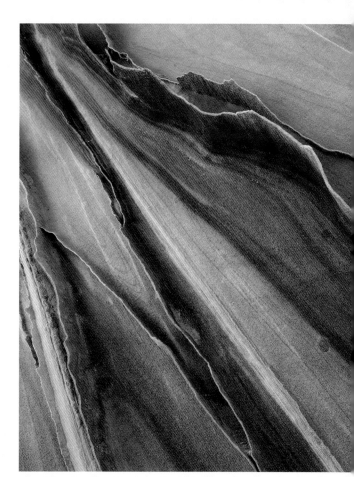

A deeper look at photography and perception

Beginnings

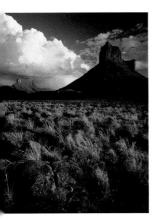

'A great work of art is like a dream; for all its apparent obviousness, it does not explain itself and is never unequivocal,' proclaimed Carl Gustav Jung, the Swiss psychologist and collaborator with Sigmund Freud. And here is the nub of the problem for photography: how can a photograph become transcendent when photography is, seemingly inherently, literal? Many critics amongst the art establishment in nineteenth-century Europe considered that photography could never be art because of its apparently overwhelming objectivity. Honoré Daumier, a nineteenth-century Parisian painter, declared, 'Photography describes everything and explains nothing.' For him, and many others, the photographic process was merely a mechanical means of recording reality devoid of artistic merit; great art was defined by its subjectivity, by the transforming vision of the great artist. These critics felt that interpretations of reality, a seeming prerequisite of artistic expression, could only take place when an art form was not directly shackled to reality, as photography was seen to be.

Artists had striven for centuries to express the universal condition of mankind by referring to archetypal characters portrayed in single works of art. They sought to evoke the general from the particular by the portrayal of the significant moment that conveyed the essence of the event, emotion or personality. Often this evocation was achieved by the use of allegory, usually by an implicit reference to classical or Biblical themes in written works external to the image. The artist's genius was expressed through his individual representation of the significant moment. The question asked was: could photography, forever bound as it was to a single specific moment, produce an image that was anything more than merely a record of what lay in front of the camera at the instant the shutter was opened? Could photography be art?

In order to satisfy their critics, early photographers seeking to establish photography as an art form had first to prove that both subjectivity and objectivity could coexist within a photographic image. The apparent bipolar nature of photography (objectivity versus subjectivity) has been the basis of many different definitions of the medium. This is a dichotomy that will crop up again and again as we look at photography and, as we shall see, it is somewhat contentious.

It might be helpful at this point to study a brief historical perspective of photography's often stormy relationship with fine art, and the leading role played by American landscape photographers, from the mid nineteenth century through to the late twentieth, in establishing photography as an art form. The body of work produced there over the last 150 years has mirrored, and occasionally led, changes in social and artistic attitudes to our environment.

Any study of American landscape photography must consider the mythological status of the American West. As Graham Caveney remarked, 'the American Wilderness is closer to a religious aesthetic than the pragmatics of geography. In its sprawling potential ... [it represents] a transcendental affirmation of national myth and personal theology'. This landscape did not conform to the nineteenth-century European concept of a pastoral idyll. It was a landscape fraught with physical dangers; the West was intimidating not only in scale but also in topography, flora and fauna. The climate and terrain combined to produce an environment inimical to representation using European tastes and sensibilities. No green pastures with lime trees beneath towering cumulus here, but instead red rock, sagebrush and the actinic desert sun.

Photography was a new medium that seemed ideally suited to recording the awe-inspiring grandeur of the new land that was just being charted. In the middle of that century vast tracts of North America were still largely uninhabited by Europeans. The US government commissioned a number of large survey projects of the mostly unknown territories to the west of the Mississippi as a prelude to settlement and exploitation by white settlers. Photography was a cutting-edge technology being harnessed for the exploration of a new frontier. The mapping and settling of the West was every bit as novel and exciting to the public imagination as our recent forays beyond the earth's atmosphere in the twentieth century; it had implications of modernity and science that were congruent with the great nineteenth-century mission of progress. Photography was 'cool' – to use late twentieth-century parlance – in the sense of being both seen as a dispassionate tool and of denoting something trend-setting and up-to-the-minute.

Pioneering survey photographers like William Henry Jackson, Timothy O'Sullivan and others working in the 'wild West' were not effete painters from a Paris salon, were not, in fact, trained as artists at all. They were hard men skilled in survival and willing to endure terrible hardship in order to photograph an untamed land. They worked on cumbersome wooden cameras producing enormous glass plates (sometimes 20x24") using the wet collodian process in extremely difficult conditions. This was instant photography compared to the processes used just a few years earlier, but it wasn't anything like modern Polaroid. Because the latent image was chemically and physically unstable, the plates had to be developed within minutes of being exposed. The photographers had to carry all the paraphernalia of the darkroom, including the chemistry and delicate glass plates, whilst travelling by mule or boat across hundreds of miles of trackless wilderness. Making an image involved not just setting your large camera in an appropriate position but also erecting the light-tight developing tent nearby, whether standing on a prairie or atop a cliff, and, having made an exposure, closeting yourself in the dark to process it there and then.

Today the images they made, of a land soon to be tamed by the flourishing US economy, seem very modern. It seems that the survey photographers wished to convey nature's splendour directly and without artifice – their work lacks the use of painterly manipulation that characterized concurrent landscape photography in Europe and the early decades of the twentieth century in America. More than this, their work eschews the compositional conventions commonly used in the eastern US and Europe.

Landscape painting in Europe had evolved, by the middle of the nineteenth century, from mere backdrops for mythical or religious subjects to the status of a subject in its own right, but had not excluded man or his work from the frame. Nature was depicted not in the raw but in relation to man's dominance over it. As the American curator and critic John Szarkowski wrote, 'in front of the wild mountain lay the green pasture with kine [cows] or sheep, or cultivated fields, or a road lined with poplars … These pictures celebrated a new sense of the cordial intent between man and Nature'. With the coming of the Industrial Revolution, nature was now less frightening, more accessible and open to lyrical and poetic interpretation in the European mind.

When Jackson photographed the Garden of the Gods in Colorado in the 1880s he seems to have placed a human figure at the base of the formation not only to confer a sense of scale to the image but also to illustrate man's apparent insignificance in such a vast landscape. As Paul Highnam noted it 'reflected his own sense of awe and respect toward the landscape' – there was little of Szarkowski's 'cordial intent' here!

But, as the American frontier moved west, so the photographic practice and sensibilities changed; a settled landscape is a safe landscape, one that encouraged a more European outlook on landscape. The landscape photographs of Edward Steichen and Clarence White, made around the turn of the twentieth century in the eastern US, are infused with a sense of tranquillity – there are no raging torrents, no barren deserts, just peaceful woods and billowing clouds. The images are often inhabited by figures borrowed from classical or pagan myths; fauns, dryads, nereids, and Pan piping amongst the trees of an Edenic landscape.

Paradoxically the apparent veracity of photographic depiction of the world, which in part drove fine art to move away from representational work into a more experimental approach, initially led photographers to try to mimic the late Romantic style of painting prevalent in the nineteenth century so as to gain credibility as an art form. These photographic 'pictorialists' sought to show that art could originate through manipulation of the processes leading to the final image. Photography in the hands of these practitioners was not innovative but regressive. It mimicked not only painterly attributes such as diffusion and brush strokes but also a European viewpoint of the landscape, rather than being a fresh approach in a new land.

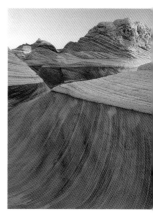

The movement that would eventually lead to photography's recognition as art, at least in the United States, began in 1902 when Alfred Stieglitz founded the Photo Secession movement with Edward Steichen and others. Stieglitz was in many ways the single most important figure in the development of photography as art in the US. Not only was his work as a photographer ground-breaking but his influence also spread through his writings, the exhibitions he held at his gallery, An American Place in New York, and his direct mentoring of some of the most important photographers of the following century including Paul Strand, Edward Weston, Ansel Adams and Minor White.

The Secessionists wanted to secede from what they considered poor photography and to install themselves as an elite. Theirs was a reaction against photography's rising popularity, against the facile snapshot and for the studied photographic masterpiece. Their stated aim, from their manifesto, was 'to compel [photography's] recognition, not as the handmaiden of art but as a distinctive medium of individual expression'. Interestingly, they saw no contradiction in continuing to produce Pictorialist photographic imagery that aped painting. Perhaps they saw themselves as having reached the status of art's younger sibling, rather than its servant, by adhering to this approach. Significantly, though, the Secessionists did see an opportunity to champion photography, with all its implications of modernity, as the quintessential American art form, giving them a new medium of self-expression and a chance to break free from the European art traditions.

The Secessionist movement published *Camera Work*, probably the most lavish and exclusive periodical ever produced on photography. Through its pages they sought to instigate a fine-art tradition in American photography, including the cult of the limited-edition photographic print later exemplified by the work of Ansel Adams. Many serious photographers felt marginalized and derided by the art mainstream and reacted by being even more passionate than their contemporaries working in other art forms, a difficult thing to do at a time when to be an artist was seen as engaging in an almost sacred enterprise! Ian Jeffrey, in *Photography: A Concise History*, sees this alienation as the cause of 'an ethos of parochialism and intransigence evident in photography ever since', and I think he has a point. As well as including intellectual articles and criticism Camera Work legitimized its photographic content as art by producing the magazine on the finest papers, using the best printing methods available and by limiting its distribution. In short they turned the magazine itself into a work of art.

Both Stieglitz and the prominent critic Sadakichi Hartmann began to tire of Pictorialism and to advocate 'straight photography'. Hartmann argued that photography would never be recognized as the 'distinctive medium of individual expression' Stieglitz had proclaimed, 'so long as [photographers] borrow so freely from the other arts as they do at present. Photography must be absolutely independent and rely on its own strength'. The first embodiments of this new ideal were the photographs of Paul Strand, to which Stieglitz dedicated the entire last issue of *Camera Work* in 1917. Strand's work is important because he confidently proclaimed objectivity as photography's defining attribute, yet was equally certain that the photograph could be a medium for subjective expression.

This fascination with photography's objectivity, coupled with its use as a means of artistic expression, was to dominate later American landscape photography. A group of prominent photographers were convinced by Stieglitz's later Secessionist approach and set up the f/64 Group in 1932. They developed an aesthetic based upon clarity of vision, a complete mastery of technique, a modernist concern for form and a celebration of nature as an expression of the sublime, an approach that has largely remained the most popular to the present day. Following on from Stieglitz's lead they placed supreme emphasis on the print as the ultimate expression of the photographic artist's work: the print as masterpiece.

As far as the story of landscape photography is concerned, Edward Weston and Ansel Adams were without doubt the most important members of the f/64 group. In terms of the overall development of photography, Weston was in many ways the more significant artist but he was not, by nature, a maker of landscape photographs. Indeed he initially thought that landscape was an inappropriate subject for photography, being 'chaotic … too crude and lacking in arrangement'; he once said, 'Anything more than 500 yds from the car just isn't photogenic.' He was a protégé of Stieglitz and the first photographer to seriously explore abstraction in the modernist fashion with his nudes and still lives. He went to live in Mexico from 1923 to 1926 in the company of his lover and model Tina Modotti, and he became acquainted with many luminaries of the Mexican art world, such as Diego Rivera and José Clemente Orozco. As well as being intellectually and emotionally invigorated by the culture he found there, his work was very influenced by the Mexican avant-garde. Upon his return to the US, he began to produce his famous pepper and nautilus-shell still lives. Working on 5x4", he produced sensual and beautiful monochrome contact prints of the images with the platinum process. The work he created exhibited a kind of super-realism, producing acuity of vision beyond the capabilities of human eyesight. In Weston's view, the subjects of these photographs weren't the objects photographed: 'Artists (fine ones) don't copy nature, and when they do record quite

literally, the presentation is such as to arouse connotations quite apart from the subject matter.' It was only much later in his life that he turned to the landscapes for which he eventually became famous.

Ansel Adams seems to stand head and shoulders above all the rest when we consider landscape photographers. Think of Adams and most photographers will instantly make a connection to Yosemite. His earliest visit to Yosemite was in 1916, at the age of fourteen, when he carried with him his first camera, the ubiquitous Box Brownie. Adams was instantly smitten by the place; he was to visit every year for the rest of his life. He later claimed that he realized immediately that his 'destiny' lay there but he still harboured the ambition of being a concert pianist until his late twenties and a meeting with Paul Strand.

Ansel Adams was one of the first great artist photographers to present nature as uninhabited; as powerful but not frightening; and as an expression of the hand of divinity. Adams' images of the American wilderness have been criticized for their wilful exclusion of the signs of man but he didn't do this because he was unaware of the threat to nature by the developments of Western civilization. On the contrary, he was a committed, tireless and outspoken environmental campaigner especially, though not exclusively, for his beloved Yosemite. He wanted to present pristine nature in a celebratory fashion in order to emphasize that it was a worthwhile endeavour to try to save it from the excesses of man.

Adams is remembered not just as a great photographer, but also as a great technician: as well as changing the way that landscape was viewed it was he who brought us the first detailed and logical system of exposure control: the 'zone system'.

Adams' technical ability is ably illustrated by the manner in which he made one of his most famous images, 'Moonrise, Hernandez, New Mexico'. Returning from a fruitless photographic trip, he spotted the fortuitous conjunction of astonishing clouds, beautiful low light and a picturesque little churchyard with, rising above it all, a pristine full moon. He and his friends tumbled out of the car and he called for each to bring him items of gear. They say that chance favours the prepared mind and this was never more true; in the panic his light meter could not be found and so the famous moment arose where he calculated the exposure of the image from knowing the brightness of the moon in foot candles (an archaic unit of luminance). He had only taken one sheet and removed

the second sheath from the double dark slide to expose a duplicate when the light faded, but it did not matter; he'd got his image.

Adams also brought us the notion of visualization: 'The visualization of a photograph involves the intuitive search for meaning, shape, form, texture, and the projection of the image-format on the subject. The image forms in the mind – is visualized – and another part of the mind calculates the physical processes involved in determining the exposure and development of the image of the negative and anticipates the qualities of the final print. The creative artist is constantly roving the worlds without, and creating new worlds within.'

The making of the image was definitely only the beginning of the process; the negative was the 'score' but the print was the 'performance' – he saw the interpretation and presentation of the raw material as critical to the success of an image. He was, naturally, as committed a technician in the darkroom as in the field, but his obsession with rendering all the available tones sometimes left his early prints a little lacking in drama, something that he himself seemed to realize in later life when he reprinted many of his most famous images in a more operatic style. His obsession with the mastery of technique was sometimes a drawback in other ways. Some of his lesser images have been criticized as being cold and clinical; the analogy has been made of music played merely competently as opposed to passionately. They have even been described as mere 'finger exercises' in the 'zone system'.

From the early 1920s onwards Adams' mentor, Stieglitz, began working on a series of photographs which he called 'equivalents'. He started with images of clouds but moved on to other subjects that prompted an emotional response in him. He described the process of photography thus: 'I come across something that excites me emotionally, spiritually, aesthetically. I see the photograph in my mind's eye and I compose and expose the negative. I give you the print as the equivalent of what I saw and felt.' He declared that photographs 'are equivalents of my basic philosophy of life'. The pursuit of this idea dominated his photography until he died in 1946. The underlying concept, borrowed from Symbolism, was that the emotion conveyed by an image was not dependant upon the subject matter but transmitted at

some deeper level by the pattern of forms and the play of light and shade. By picking increasingly commonplace subject matter and shooting it in an abstract manner he sought to show that the great artist (in which category he naturally included himself) could explore the depths of the human psyche. One of his spiritual disciples, Minor White, described the concept thus: 'If the individual viewer realizes that for him what he sees in a picture corresponds to something within himself – that is, the photograph mirrors something in himself – then his experience is some degree of Equivalence.' This is just another way of expressing the notion of transcendence that I mentioned at the beginning of this chapter. This search for 'equivalence' began a swing towards the mystical, which Minor White and others would take up after Stieglitz's death.

Minor White is in some ways a forgotten master of photography. His mystical outlook often seems out of step in today's secular and commercial world and consequently his views have fallen out of favour. He was not a great rational thinker like the philosophers and linguists we'll encounter in the next section who theorized about photography from an external perspective. He was an artist first and foremost and his notions tend to be romantic and intuitive (a point perhaps best illustrated by the fact that he spent four years writing poetry after his graduation). Nevertheless, his development of Stieglitz's notion of 'equivalence' was an important step in the development of theories about photography and its practice in the late twentieth century.

White became interested in photography at the age of eight, when he too, like Adams, was given a Box Brownie camera. But his eventual pre-eminence as a photographer and teacher was by no means a certainty. He developed a passion for botany and creative writing in his teens and it was not until he was almost thirty that he abandoned these interests to concentrate on photography. At the end of World War II, aged thirty-eight, he moved to New York and began working with Nancy and Beaumont Newhall at the Museum of Modern Art. He found himself at the very heart of photography, surrounded by some of the greatest thinkers, teachers and influential critics in photography. Whilst at the Museum he met many of the leading photographers of the day, including Edward Weston, Harry Callahan, Paul Strand and Alfred Stieglitz.

The meeting with Stieglitz in the last year of his life was a defining moment for the future direction of White's photography. He seized upon the notion of 'equivalence' as a way of understanding how photographs convey meaning and as a central guiding principle in his own practice. White developed 'equivalence' into a complex notion. For him, 'equivalence' was a process mediated by photography rather than simply a way of making images or a stylistic approach. Critically, White stated that both the making and viewing of 'equivalents' are active processes; the viewer must participate for the 'equivalent' to function. At its root was the assumption that, as he wrote, 'the following equation is factual: Photograph + Person Looking = Mental Image'.

He saw the style or content as irrelevant: 'Equivalence is a function, an experience, not a thing. Any photograph, regardless of source, might function as an Equivalent to someone, sometime, someplace.' This is art functioning as communication rather than frivolous self-expression. Here was a way to reinforce photography's credence within the wider art world as a valid means of artistic expression. White proclaimed that if a photographer 'uses Equivalency consciously and knowingly, aware of what he is doing, and accepts the responsibility for his images, he has as much freedom of expression as any of the arts'.

For a photograph to function as an 'equivalent' the photographer first had to recognize something in the external world as equivalent to his concerns or emotions. The subject of the photograph that is then made is not the object in front of the camera, but rather the feeling that the photographer is trying to convey. White intended it as a deeply personal, spiritual, multifaceted and subtle process – not a simple symbolic replacement using obvious cultural references. The vital second stage of the process is for the viewer to recognize the exact same 'equivalence' in the image. The photographer's task is to ensure this through their selection of framing, timing and presentation.

In a meeting at Ansel Adams' home in 1951, Minor White and a number of like-minded friends discussed what they felt was the parlous state of photographic publications and resolved to start their own magazine. Nancy and Beaumont Newhall, Dorothea Lange, White and others founded *Aperture* magazine the following year. It was meant in many ways to be the spiritual successor to Stieglitz's *Camera Work*. The quality of the writing and photography was of the highest order and, though often struggling financially, it has remained in print to the present day. The magazine became an important conduit for White's

ideas and he remained editor until the year before his death in 1976. Aperture Press published White's seminal work *Mirrors, Messages and Manifestations* in 1969. The images and text sum up White's journey through photography following the path of 'equivalence'. In the 1950s and 60s White taught workshops from his base in Rochester, New York state. He was a somewhat overpowering tutor which sadly meant that many of his students never escaped from under his shadow; those who did included Paul Caponigro, Walter Chappell, Nathan Lyons and Jerry Uelsmann.

John Szarkowski, though not a photographer, has been described as the most powerful man in photography in America. He became curator of photography at the Museum of Modern Art (MoMA) in the early 1960s, at the age of thirty-six, and held the post to the late 1980s. During his tenure he organized several important and critically acclaimed exhibitions that, along with his writings on photography, have been widely influential.

The 'Mirrors and Windows' exhibition, held at MoMA in 1978 and accompanied by a book, was perhaps the most significant organized during Szarkowski's tenure. He proposed that all photographs could be classified as either 'mirrors' or 'windows'; mirrors tell us more about the photographer whereas windows tell us about the world. This categorization applies as much to the expressed or inferred intent of the photographer as to the resulting image. Photographers who produce mirrors are concerned with Romantic self-expression and the work is often overtly stylistic, strongly concerned with form, their subjects tend to be abstract both in conception (e.g. resilience or love) and presentation; the photographs mirror the concerns of the photographer. Photographers who make windows, on the other hand, are concerned with exploring the world and the work is less stylized, more documentary in manner, their subject matter is more specific, rooted in a particular place and time; the photographs are coolly revelatory. Szarkowski's definition of 'mirrors' encompasses Stieglitz's notion of 'equivalence'.

Which, in a sense, brings us full circle, for the heart of this definition is yet another way of dividing photography into two camps: the subjective and the objective. By the 1940s it was obvious to all but the most diehard critic in America that photographs were a legitimate means of artistic expression, that they were capable of combining the objective and the subjective and that the result could be transcendent. But the question of where this second order of meanings might arise

from was rooted in a mystical rather than philosophical definition.

Landscape imagery in art photography has moved on from Adams et al, indeed it was doing so in their lifetimes. The baton has been passed to figures like Harry Callahan, Paul Caponigro, Brett Weston, Wynn Bullock and on, in the 1980s to Lewis Baltz and Robert Adams with their coolly rational 'New Topographics'. It cannot help but have done so because art is in a constant state of flux and renewal, the sole purpose of the game sometimes seems to be to avoid repetition – whether you have something to say in a new way or not. But in the wider world Ansel Adams'

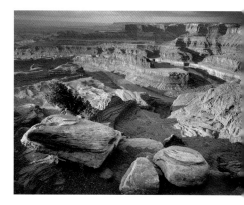

perspective of our natural world still holds sway because many of our attitudes to nature are still trapped in the nineteenth century, caught at the moment when we divorced ourselves from the rhythms of our environment. All the dire warnings of global catastrophe from climate change and habitat destruction are not going to make us want to look at images of these things, in fact quite the contrary. When we look at landscape we want to see an ideal and not the reality. We are searching for a primordial connection to nature that has been lost in our everyday lives; we are searching for peace; room for contemplation; and we are searching for beauty.

In Plato's Cave

Let's think about how we make sense visually of the world around us. The great Greek philosopher Plato wrote an allegorical tale about a group of prisoners held captive from birth in a deep cave. Their only experience of the outside world comes from flickering shadows cast on the wall of the cave. What can they know of the world beyond their cave, reality, from this second-hand information? Yet are we not all prisoners in the cave of our skulls, experiencing visual reality from the images projected on to our retinas? If what we see is truly real then there could be no possibility for hallucination or optical illusion, yet, as we shall see, these are commonplace experiences.

We accept the miracle of vision as our birthright, yet we aren't born with the ability to see fully developed – we have to learn to interpret the pattern of light projected onto the retina. It's important to realize that how we see isn't solely, or even chiefly, the domain of our eyes; vision is a synthesis of light, physical feedback and mental processing. The human eye is a truly amazing mechanism; we are each equipped with two autofocus, auto-exposure devices using constantly variable apertures that can comfortably and instantly produce a three-dimensional image over a huge range of luminance (from midday sun to deep twilight) with ancillary software that automatically colour-corrects the input. In some ways the eye is just like a camera, but in other ways human vision is radically different; the iris will, for instance, change size according to how aroused we are by the subject. And, as we shall see, this incredible adaptability to lighting conditions doesn't always work in the artist or photographer's favour.

It is useful to study this interaction between our eyes and our minds to help us understand how we view photographs and, I hope, show how we might become more adept at making them. We need to move from an understanding of the image as a beautiful object to a deeper understanding of how the viewer interacts with that image. I intend to split this study into two distinct areas.

The first concerns the basic mechanics of how we see, the acquisition and initial processing of light, the visual data, into a model

of our surroundings. How do we transform the patterns projected onto our retinas into something that we perceive as a space, something having depth, width and height? How might we then apply these processes in order to interpret a photograph?

The second concerns a search for what other information, beyond the simple visual description, we might derive from an image. For transcendence in an image to be possible there must be hidden meanings beyond mere description, perhaps ones we understand subconsciously. Where in the patterns of the image might these hidden meanings reside? Do these meanings constitute a non-textual language and if so how do we read it? Is our understanding of this language innate or learnt and can we be certain what the artist was trying to say?

Let's start with the basic mechanics. Steven Pinker, in *How the Mind Works*, writes that 'vision is an ill-posed problem'. It is 'ill-posed' because there is no single definitive explanation that solves the problem of how we translate the pattern of light continuously projected onto our retinas into a three-dimensional map of our surroundings. You might find that surprising as we take for granted that we understand what we see and assume that there is only one correct way to look. Indeed, perceptual psychologists are probably the only people who normally worry about how we see. To prove how intractable and basic the problem of vision is let's consider a simple two-dimensional shape; imagine a white square suspended vertically in a black space in front of you. Now imagine in its stead a white trapezium with the shorter of its two parallel sides at the top. Here's where it gets tricky: from the pure visual information projected on to the retina this shape could indeed be a trapezium but it could just as easily be a square tilted backwards away from the viewer or, indeed, towards the viewer. In purely logical terms either scenario could be correct. So how do we know which it is? There must be some additional processing or physical inputs that solve these problems for us.

Well, most of the time this is so, but not always! We've all seen a variety of optical illusions that trick us into believing that parallel lines aren't or that small circles are bigger than larger circles. Optical illusions play with our expectations about how space is organized. One of the simplest is a wire frame drawing known as a Necker cube.

Stare at this long enough and your perception of this object will flip from a downwards view of its top face to an upwards view of its bottom face and back again. That's weird enough, but have you ever stopped to think why we see a two-dimensional drawing as a three-dimensional shape at all?

The Dutch artist M. C. Escher delighted in producing more elaborate illusions and perhaps the best known of these works is his drawing of a looped, never-ending staircase. Logic dictates that no such structure can exist but our eyes insist that it does. The artist turned psychologist Adelbert Ames Jr. created some very intriguing three-dimensional illusions. They are an evolution of Victorian peephole illusions. In one of these a view through a keyhole shows a richly decorated room but when the door is opened the room is bare – the sumptuous room is in fact a doll's house fixed over the keyhole. Ames created elaborate fixed viewpoint illusions which play with our sense of perspective. They include a room in which a child at one side appears bigger than its parent at the other side and another in which a simple chair is seen to be a widely separated collection of geometric shapes when viewed from anywhere other than the intended viewpoint.

Whatever their content, these illusions challenge the very foundations of how we perceive reality. They pose the basic question 'can we believe our own eyes?' Well obviously we can most of the time because we don't habitually walk into walls or fall off cliffs. We shouldn't despair that our eyes deceive us because illusions help perceptual psychologists to solve the problem of exactly how we make sense of the world and to find the limits at which our mental spatial routines break down. As we shall see, the problem is not with the visual information per se but rather with our mental processing of it.

The ability to see in three dimensions is conferred on us thanks to our binocular vision. Incredibly no one understood this until the scientist Charles Wheatstone discovered human stereoscopic vision in 1838. It had always been assumed that we had two eyes merely for reasons of bilateral symmetry – two arms, two hands, two legs, two lungs so why not two eyes as well? There seemed no compelling reason for us not being like the mythical Cyclops, other than perhaps for reasons of redundancy. It might, after all, be useful to have a spare in case you lost an eye in an animal attack. The mind does such a good job of combining the separate images from each eye that, apart from Leonardo da Vinci, no one had noted before Wheatstone that each eye had a slightly different viewpoint. This apparent unity in our binocular vision is fittingly referred to as 'cyclopean'. Even Leonardo had not realized that binocular vision afforded us the ability to determine the relative depth of objects in our field of view. So how does stereoscopic vision work? There are basically two sets of processes at work, one physical and the other mental.

We use three different types of physical feedback from each eye to ascertain depth.

First, our mind monitors the thickness of the lens in our eyes. Unlike a camera we cannot move the lens relative to the image plane, so in order to focus an image on the retina, for different eye-to-object distances, the shape of the lens must change. The lens is thicker when focused on a close object and thinner when focusing further away.

Second, our brains take note of the angle subtended by our eyes (imagine a line projected from each eye toward infinity running from the centre of the retina [the fovea] and through the middle of the lens). When focused at infinity our eyes are almost parallel to each other but, as we focus nearer, they converge, meeting at the progressively nearer position that we are focusing on. Try focusing on your finger at arms length then, keeping it in focus all the while, move it in toward your face. You will become increasingly cross-eyed.

Third, we take in to account the position in which each object is projected onto the retina. Imagine three objects in a line running straight away from the viewer; the nearest object will be projected in a position toward the outside of each eye and the furthest toward the inside.

We use a combination of all three physical data to produce a two-and-a-half dimensional image (in fact, strictly speaking, it's geometrically still only two; the brain processes the information to provide the extra half dimension).

So, we've now got two images projected onto our retinas and we are able to determine how far away parts of each image are. But that doesn't mean that we can actually make sense of the visual information; to do that we need to employ a

number of purely mental routines. This mental processing is extremely complex but three routines in particular refer to how we understand two-dimensional images. I mentioned earlier that we have expectations about how space is organized and these routines are built upon some of those expectations, the paramount one being that the world doesn't set out to trick us – that our environment is not inherently deceptive.

Amongst other things, we also assume that:

• objects are evenly coloured and textured and apparent changes are due to changes in perspective and lighting
• an apparent diminution in size is due to an increase in distance from the viewer
• objects have easily discernible outlines.

So, when we view a scene our minds scan it for clues so as to process it using these assumptions.

We look for a change in tone: we assume that a gradual change in tone denotes a curved surface and that a marked change shows a bend, a fold or the edge of a surface.

We look for diminution in scale: we assume that the smaller sheep must be further away than the big one though this is only a product of the projection of an image on to our retinas; we know that if we could perceive reality otherwise we would see that the sheep are roughly the same size. We expect texture to diminish with distance as part of the scaling effect but this is also due to the grain of our vision. The smaller the area covered by an image projected onto our retinas the fewer the receptors available to process the data, therefore the more detail that is lost. We also expect parallel lines to converge with distance – more on this in a while.

Finally, we look for objects overlapping to show that one is in front of the other (we assume that there isn't a chunk missing from one object that just happens to be filled by the other, as in Ames' chair illusion).

It will be apparent from this brief description of human vision that when we view a photograph, or any two-dimensional artwork, we cannot

be reliant upon our body's physical feedback system for understanding the description of space. Instead we fall back on the purely visual cues transmitted in the pattern in order to assess depth. In fact it is very important when making decisions about composition to be aware of the differences between monocular and binocular vision, otherwise we run the risk of producing an image that, whilst easy to interpret in three dimensions, is difficult to understand when transformed into a photograph.

The 'ill-posed' problem isn't just with shapes, but also with tones and colours. How do we know whether a grey shape projected onto our retinas is something light enveloped in shadow or something dark in full sunlight? They might conceivably be the same luminance yet we know that one is 'white' and the other 'black'. We know by making complex comparative analyses of the tones in our surroundings. In contrast, a light meter assumes that everything is a mid grey because it cannot know otherwise. The human system of comparison helps us to understand where to place tones in a photograph but the fact that our eyes constantly adapt to light levels around us, often without us being conscious of the process, means that we can have problems assessing exposure. Even in extreme circumstances, as when we look from deep shadow to full sunlight, this adaptation is almost instantaneous. For photographers the system is, in a sense, just too good – it's easy to overlook a change in light level. I've been caught out by this many times!

The problem of dealing with colour is even more complex. All photographers and painters know that light doesn't come in just one colour. Manufacturers produce different films that are balanced for the two most common lighting situations; daylight and tungsten. If you've ever inadvertently photographed a subject using daylight film in tungsten light you'll know just how big a colour difference there is between the two light sources. Yet as you sit reading this book in either daylight or artificial light, the paper appears to be white and the colours in the photographs don't exhibit a colour shift. Normally, we are somehow completely unaware of colour shifts in light, only noticing them in mixed lighting conditions – as when we look at twilight into a home lit with electric light. How can objects appear to be the same colour if the colour of the light is so different? Edwin Land, the inventor of Polaroid, studied this problem of colour constancy for many years and developed the Retinex theory (the word is a concatenation of retina and cortex).

What he realized is that, as we've already seen, human colour vision is comparative rather than absolute. Our eyes don't quantitatively measure the wavelength of light reflected off objects, as a spectrometer would, rather they make a qualitative assessment – which is one of the reasons why hardly anyone can agree on what colour turquoise is. We compare all the colours in a scene to arrive at an overall colour balance. If all the colours are shifted towards yellow then our brains apply colour correction. Hence a banana still appears yellow to us in tungsten light, fluorescent light or daylight. However, our brains can only perform this correction if the scene in front of us has a wide range of colours and is illuminated by a broad-spectrum light source. We are unable to make a correction when the light source has a very limited spectrum, such as a red safelight in a darkroom or the sodium vapour lamps commonly used as streetlights. All this amazing corrective ability has a downside: we don't always see the true colour of light, whereas film usually does.

John Szarkowski suggested six transformations between reality and a photograph:

1) from three dimensions to two dimensions
2) from unbounded to enclosed within a rectangular frame
3) from multiple views to a single camera angle
4) from perpetual flux to stasis
5) from life size to another scale
6) from colour to black and white.

The first five of these are inherent in the production of every photograph; the last, obviously, only applies to monochrome work. For (2) through to (5) the photographer controls the nature and degree of the transformation by selecting one or several of the following: the viewpoint, the focal length of the lens, the depth of field and the shutter speed.

There is at least one more transformation that Szarkowski omitted from his list, namely altered perspective. He might have thought this a subsidiary effect of the fifth transformation but I think that it's more fundamental (of course, photographs can, rarely, be life size so the fifth transformation doesn't always apply). The human visual field does not correspond to the field of view of any camera. Our eyes encompass an elliptical field of view of approximately 150 degrees vertically and 180 degrees horizontally; we have better peripheral vision laterally simply because of the positioning of our eyes in our head. But we do not take in the whole field in one go – we are aware of it all but only the portion of the field that is covered by the fovea (the central part of the retina) is ever sharp. This central portion, sometimes called macula vision, corresponds to how vanishing point perspective is rendered in most art and also the coverage (approximately 47 degrees) of a 'standard lens'. We build up a sort of mental mosaic of our surroundings by constantly scanning our eyes across the field of view; in fact if our eyes cease to move for long enough the receptors cease to respond. Whilst we can simulate the effect of a telephoto lens by focusing our attention on a small area of our surroundings (as we do when we point the fovea at something distant that interests us), this doesn't produce the same compressed perspective nor the level of detail possible through optical magnification. The change in perspective between our vision and that of a super-wide-angle lens is even more marked. The exaggerated perspective with a looming foreground and diminished background produces an effect beyond human vision.

What about the question of how we recognize a two-dimensional image as a representation of space? For some time there was a myth prevalent in anthropology arising from some studies which purported to show that 'non-visual' cultures were unable to recognize familiar objects when portrayed in photographs. Michael Forrester points out, in *Psychology of the Image*, that were there some barrier of comprehension between a photograph and the viewer it would 'put into relief the claim that the photograph "captures" reality, in the sense that what is represented has some kind of one to one relationship to whatever was photographed'. More recent analysis has shown that we don't need to consciously learn how to see photographs as representations of reality. The psychologist Paul Ekman, in a 1975 study, showed photographs of American students' faces to New Guinean highlanders. Far from being unable to understand the images, the New Guineans had no trouble recognizing facial expressions from two-dimensional representations of people in a completely different culture. Interest amongst Ekman's peers was focused on the highlanders' recognition of emotion, which had been thought to be culturally relative, but as photographers our interest must be in the fact that, as Steven Pinker wrote, 'they were seeing anything in the photographs at all rather than treating them as blotchy grey paper'.

Our ability to understand a two-dimensional representation of a three-dimensional space shouldn't surprise us, since humans have been making such images for at least 30,000 years, as evidenced by cave paintings at sites like Lascaux in the French Pyrenees. Human vision is already an interpretation of the two-dimensional projection of the exterior world upon the retinas of our eyes. The mental processes that

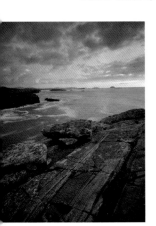

resolve this information should have little difficulty in interpreting a pencil drawing, oil painting or a photograph. However, the problem of interpreting two-dimensional images was considerably more abstract before the widespread adoption of Albertian (vanishing point) perspective during the Renaissance.

Paintings from the Paleolithic era, through the Egyptians and on to the early Middle Ages in western Europe, depicted reality according to a number of different formalized and ideological perspectives. In paintings from the Middle Ages, for instance, there is often scant regard for depicting signs of depth; figures do not always diminish in size with distance, for instance, especially not if the figure is royalty. A king could always count on being the largest man in a painting, even if he was only 5ft 2ins in real life. He was the 'big man' and the scale of his portrayal reflected his social status not his apparent depth within the image.

A consistent representation of scale is the most important clue that we use to understand an image as a representation of a three-dimensional space. American comedian Stephen Wright cleverly played upon the relationship between scale and distance in an account of how he once had a close encounter of the third kind. He witnessed the landing of a very impressive star ship from which emerged a number of 1-inch high aliens. Astounded he said, 'Gee you guys are really small!' 'No', they insisted in perfect, but weary, English – as aliens always do in these circumstances – 'No, we're just a very long way away.'

Naturalistic perspective drawings place the viewer of an image in the same position as the artist, the focal point, with a unified depiction of scale that employs the same optical laws of physics as the image projected onto our retinas. Using perspective is simply naturalistic rather than ideological – rational rather than irrational. As Leonardo da Vinci wrote, 'Perspective is nothing else than seeing a place behind

a pane of glass … on the surface of which the objects behind the glass are painted.' The classic method of demonstrating perspective was to draw a scene including a floor paved with square tiles. As objects recede from a viewer they reduce in scale, and so must the tiles in our drawing. The furthest edge and sides of each must then be shorter than the nearest edge and so each square tile becomes a trapezium (as in our original example). Since they are laid in parallel courses, any joint lines along their left-hand and right-hand edges must converge with distance. Convergence of parallel lines in a scene is, then, merely an effect of scale, though no one realized this until the Renaissance.

Perspective came as a revelation to the Renaissance world but is inherent in photography because the image projected onto the film obeys the same laws. Indeed, various optical devices such as the camera obscura, and later the camera lucida, were developed over the years to assist painters in making perspective drawings by projecting an image onto the canvas. These devices were the direct ancestors of modern photographic cameras.

Hopefully you can now begin to understand some of the correspondences and differences between human vision and the photographic image. Let's now turn our attention to looking at the secondary information in a photograph and the possibility of a visual language and what its basis might be. For an image to achieve transcendence it must contain inner meanings beyond the mere depiction of the subject. How do these inner meanings arise if there is no accompanying text?

Perhaps the first thing that we do when we look at a photograph is to look for things we recognize and mentally to attach labels to these objects (of the kind 'tree', 'river', 'hill', 'sky' and 'cloud'). Our reading of these elements would seem straightforward enough but objects often stand for things other than just themselves. One need only think of how living things have been used as symbols to suggest specific attributes; a lion for valour, an oak for strength or an owl for wisdom. Because photography is innately, and often overpoweringly, representational it's sometimes hard to realize that what we see in a photograph might suggest something other than just itself. But, we've already seen that for adherents of the mystical tradition in photography, from Stieglitz and Minor White onwards, a cloud in a photograph isn't always just a cloud.

At the beginning of the twentieth century a group of philosophers began looking, as Daniel Chandler noted, 'for "deep structures" underlying the "surface features" of phenomena'. These 'Structuralists' included the Swiss linguist Ferdinand de Saussure, who proposed a study of signs; anything that signifies something to us and not just the kind that read 'Keep off the Grass' or 'No Waiting'. Signs can exist as text, images, sounds, smells, facial expressions or physical gestures. Signs can be grouped into languages (body language for instance) in the same way as words, though the boundaries between these languages are not as distinct as those between spoken languages. Signs are literally anything that communicates a meaning or emotion to us, whether that meaning can be expressed in words or not. Perhaps appropriately, philosophers can't agree a name for the study of signs; it is known variously as semiotics or semiology – it hasn't even been agreed whether linguistics is part of the study of signs or vice versa! I will frequently refer throughout the rest of the book to the insights of Frenchman Roland Barthes who was for many years, until his death in the 1980s, the leading theoretician using semiotics to analyse photography.

Linguists, like Saussure, realized that words are arbitrary symbols: there can be no innate link between the object and the word attached to it. Such a link would deny the possibility of naming the same thing 'dog', 'hund' or 'chien' – it would preclude the existence of more than one language. This arbitrary nature extends to all other sign systems and therefore any sign may have a multiplicity of meanings. Consider, now, how a photograph of a single crooked tree atop a rocky hill might stand for 'loneliness' or 'deforestation' or 'perseverance' or 'old age' or 'life' – or maybe even 'wind'. Semiologists would recognize the tree as a sign and refer to its 'standing for something else' as connotation and its 'standing for itself' as denotation; so our example tree would, amongst other things, denote crookedness and hawthorn and might connote life and loneliness. As soon as you place two connotations next to each other the complexity of the result is much greater than just double, since it calls to mind yet more signs that evoke the same idea. The principal difference between words (so-called natural language) and other kinds of signs is that words have widely accepted definitions of meaning (otherwise there could not be dictionaries) whereas the latter usually do not – though of course the meaning of some is prescribed: just think how much more chaotic our roads would be if we didn't all agree on what road signs meant! This is because our reading of signs other than words is, as we shall see, both culturally specific and partly subjective. It is also because, as Emile Benveniste asserted, 'We are not able to say "the same thing" in systems based upon different units.'

Others, though, have asserted that all other signs can be expressed in written language; Marvin Harris opined that 'human languages are unique among communication systems in possessing semantic universality … [in being able] to convey information about all aspects [of experience] whether actual or possible, real or imaginary'. He has obviously never been 'lost for words'! Just think about how inadequate words can be for describing smells or colours and you will see that, whilst it may be true that we can describe anything with them, words are not truly equivalent to the thing described. In a similar vein, Szarkowski wrote, 'The meanings of words and those of pictures are at best parallel, describing two lines of thought that do not meet. If our concern is for meanings in pictures, verbal descriptions are finally gratuitous.'

Barthes wrote in his last book, *Camera Lucida*, 'A photograph is always invisible, it is not it that we see.' He meant that the meaning we gain from a photograph derives from a whole range of signs and symbols that we understand in a wider context external to the image. The key point is that we read a photograph; viewing one is an active, not a passive process. Some of these signs appear to be universal (e.g. some facial expressions), others are widespread but culturally specific (e.g. religious symbols) and still others are peculiar to the individual viewer arising from their personal experiences. The response to some other signs is very deeply seated, perhaps even hard wired. Research has shown that some of the light entering our eyes transmits signals directly to the hypothalamus, one of the oldest parts of the brain and part of the limbic system. Light shifted towards either the red end or the blue end of the spectrum evokes an instinctive emotional response from the limbic system relating to temperature. We even call these colours, respectively, warm light and cold light.

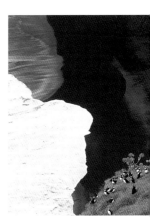

All forms of visual representation, including photography, share one attribute; the image is not only a mirror for the artist's experience but also for those of the viewer. The meanings that we extract from an image are necessarily flavoured by individual responses since every viewer brings his or her own intellectual and emotional baggage to the viewing. The precise source of

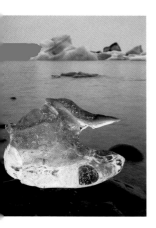

these personal responses is by rights the domain of psychology and psychoanalysis in the Freudian or Jungian tradition and beyond the scope of this book, but we must always be aware that these personal responses are inevitable. This individuality of response means that not only will single signs evoke different connotations for different people but also that any given sign may evoke no response at all in some individuals. There will be common points of contact but also areas where meaning drifts for each individual, in the same way that no two people will get exactly the same meaning from a poem. Just as the conjunction of words produces indefinable and unstable thoughts and feelings which change from one person to another, and sometimes subtly from one reading to the next, so the effect of an image on the viewer changes from one person to another. For some the reflection of the photographer's viewpoint by the image is smooth and almost perfect, for others it resembles more the grotesque distortions encountered in a fairground hall of mirrors.

The problem for Stieglitz's notion of 'equivalence' is that not only should the object photographed evoke an emotional response in the photographer but that, by dint of his expertise and insight, he is thought able to evoke the exact same response in the viewer. In Szarkowski's terms the photograph is mirroring the photographer's concerns and presenting them as a perfect reflection to the viewer. This could only possibly be true if there were single fixed meanings for visual signs and, as we have seen, there are not. Minor White offered little practical advice on how to achieve 'equivalence' beyond his somewhat gnomic comment, 'When a photograph is a mirror of the man and the man is a mirror of the world, Spirit might take over.'

However he seemed to realize that something more than a simple intent to express emotional response was needed because he added, 'It follows that "self-expression" as the aim of the photographer is not in itself sufficient.'

There can never be a guarantee of 'equivalence', only a striving towards it. Individual responses do not mean that interpretations are cut entirely adrift, at the mercy of currents of meaning. The photographer suggests a course by the content of the image but cannot ensure that the viewer will reach the intended destination. The reading of an image can be directed further by captioning the image, which serves to emphasize certain aspects over others.

Is, then, a common inner meaning really unreachable and if so aren't we then left just with the surface gloss? Photographer and theorist Victor Burgin insists that a single common meaning beyond a simple description of the contents of the photograph is indeed unreachable because, 'There is no language of photography, no single signifying system … upon which all photographs depend.' We are definitely not left with the surface gloss, but rather with a very complex set of signs to decode. In any single photograph we will read a lot of different signs, often from totally different sign systems. In a portrait photograph we might read signs relating to the style of photography, body language including facial expression, clothing, age, era, location, social status, race and so on. Some of the processes by which we read these signs are conscious but many are not. The photographer cannot know how the viewer might respond to any one of these signs, let alone the entirety of signs within the image.

I hope that this foray in to semiotics hasn't led you to feel that, as one critic dryly remarked, 'semiotics tells us things we already know in a language we can't understand'.

We must remember that whilst experience teaches us what does not work it doesn't teach us what will work until we've tried it.

Technical information

Working on large format forces the photographer to slow down. The ritual allows time to analyse the problem, to look at many different solutions and provides an opportunity for incubation before illumination.

On this page I've included examples of pictures made with the six different focal length lenses that I use. All the images in this book, unless stated otherwise, were made using Fuji Velvia Quickload on a Linhof Technikardan 5x4" folding monorail camera.

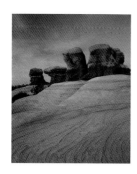

The Devil's Garden, Escalante,
Utah
Linhof Technikardan
90mm lens
30 sec, f16
Heliopan warm tone polariser
Velvia Quickload 50

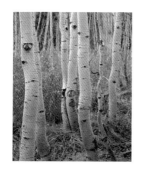

Cedar Breaks, Utah
Linhof Technikardan
150mm lens
1/8th, f16
81b
Velvia Quickload 50

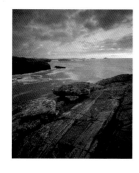

Garennin, Isle of Lewis
Linhof Technika
65mm lens
2 sec, f22
Lee 0.75 ND graduated filter
Velvia Quickload 50

Virgin River, Zion, Utah
Linhof Technikardan
270mm lens
16 sec, f16
81b filter
Velvia Quickload 50

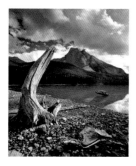

Emerald Lake, Yoho, Canadian
Rockies
Linhof Technikardan 72mm lens
1 sec, f22 1/3
Heliopan warm tone polariser, Lee
0.6 ND graduated filter
Velvia Quickload 50

Virgin River, Zion, Utah
Linhof Technika
300mm lens
1 sec, f22
No filter
Velvia Quickload 50

Index

Acknowledgements

My sincere thanks go to:

Joe Cornish for believing in me when I didn't always believe in myself

Phil Malpas and Clive Minnitt for being a never-ending source of friendship, fun and encouragement, as well as fellow members of the world's most exclusive club – 'The CUBS'

Charlie Waite for being a shining example of great talent combined with humility, and for giving me the opportunity to improve my photography through many wonderful experiences with Light & Land

Keith Wilson and Ailsa McWhinnie for encouraging me to start writing – even if they didn't always approve of all the 'big words' I used!

Barry and Alistair at The Darkroom for their generosity and superb processing skills

Eddie Ephraums for having the vision to commission this book, the skills to produce such a wonderful design and the stamina to see it to fruition

Everyone else who helped make this book a reality.

Finally, a huge thanks must go to Jenny and my children, Isabelle and Tilly, for their patience in putting up with me whilst I struggled to produce the text. I'm sorry that I was grumpy and lost working on 'the book' for so long.

Dedication

This book is dedicated to the memory of John Ward (1926–95) for giving me the courage to pursue my dream.